n. 1 - 200

To :Eva,
 Someone
positive role model for me during
my high school days at Berkeley
Institute.
As you read, you will readily
identify with my struggle for freedom,
 justice and ● equality in
 BERMUDA!

Let
JUSTICE
flow

A BLACK WOMAN'S STRUGGLE FOR EQUALITY IN BERMUDA

Sorry I missed seeing you this
summer.

MURIEL WADE-SMITH

All the best to you and
your family!

WINEPRESS WP PUBLISHING

Muriel M. Wade-Smith

Packaged by WinePress Publishing, PO Box 428, Enumclaw, WA 98022. The views expressed or implied in this work do not necessarily reflect those of WinePress Publishing. Ultimate design, content, and editorial accuracy of this work are the responsibilities of the author.

Scripture quotations are taken from the King James Version of the Bible.

ISBN 1-57921-147-X
Library of Congress Catalog Card Number: 98-61304

In Memoriam

Let Justice Flow is dedicated to the memory of my precious son Ashanti Keino Smith, who sadly met an untimely and tragic death on May 2, 1998, at the tender age of twenty-five, when he became Bermuda's seventh road fatality.

Ashanti, I remember once, when you were six years old, you said, "Mommy, I hate to tell you this, but school is boring. I have a better idea: Why don't you let me stay at home, and you teach me?"

It took me four years to grasp the significance of what you were saying, and when you were ten years old and your older brother, Gareth, was fifteen, I removed you from the public school system and taught you myself. Out of this evolved the founding of PEAL Mission Academy. PEAL means "People Excited about Loving, Living, and Learning."

About a year before you passed, I vividly recall the Sunday afternoon when you and Gareth came into my bedroom. During our conversation, you both indicated to me, "Mommy, what you did for us was the best thing that happened to us.

It was the only thing that worked for us, and that's what we want for our children."

Why did you have to die? Our hearts have been deeply saddened by your passing. Since your death, however, I've seen God's deeper purpose for your life. I've asked myself the question, *Was my baby son the sacrificial lamb that had to be slain so that my dream of Christian education for Bermuda's children could become a reality?*

You have caused this flame to be rekindled and reignited. About fifteen years ago, when I was convinced about providing Christian education for you and Gareth, the verses found in Matthew 7:9–11 assisted me in making the decision. Just recently, I have felt a resurgence of that same feeling, and it compels me to provide Christian education for your children—my grandchildren. I share those verses here:

> Or what man is there of you, whom if his son ask bread, will he give him a stone? Or if he ask a fish, will he give him a serpent? If ye then, being evil, know how to give good gifts unto your children, how much more shall your Father which is in heaven give good things to them that ask him?

Ashanti, your untimely passing has made me know that you have been the real pioneer of Christian education in Bermuda. My vision for Christian education has gone beyond the twenty-one square miles of our homeland, Bermuda; and now I have a wider, global perspective that includes quality Christian education for Black children in the Caribbean, Africa, and the inner cities of the world.

My sincerest and deepest heartfelt appreciation! A compelling force that will turn a tragedy into triumph and bring meaning to a meaningless loss drives me to provide quality

Christian education for your children and for Black children all over the world.

I close with a poem that brought me comfort as I walked every morning in Lewisville, Texas, shortly after your death.

His Journey's Just Begun

Don't think of him as gone away—
His journey's just begun.
Life holds so many facets—
This earth is only one. . . .

Just think of him as resting
From the sorrows and the tears,
In a place of warmth and comfort
Where there are no days and years.

Think how he must be wishing
That we could know today,
How nothing but our sadness
Can really pass away.

And think of him as living
In the hearts of those he touched,
For nothing loved is ever lost—
And he was loved so much.

—*E. Brenneman*

Acknowledgments

My sincerest thanks and heartfelt appreciation goes to my family and friends who have supported me with their prayers and financial assistance over the past twenty years. They have kindled that indomitable spirit in me and have made me realize that my struggle went beyond securing a job in my native land; the struggle embraced and encompassed the greater battle of fighting for *freedom, justice,* and *equality* for my fellow countrymen.

What would I have done without the genuine assistance and concern of two of my younger compatriots, Zena Francis and Tonita Eversley, who always knew what to say and what to do to encourage, motivate, and inspire me! They showed me that they had the greatest confidence in my ability to do a first-class job in writing this book.

Special mention must be made of my dear Canadian friend, Susan Kemp. Thanks for being there when the way seemed so dark and hopeless. I appreciate your honesty,

your straightforwardness, and your willingness and patience to proof the manuscript. Your suggestions and comments were most helpful.

Words are inadequate to express my deepest appreciation to Henry and Ilene Joell and their sons, Paul and David. Every visit to your home in Long Island, New York was just the tonic I needed to be revived and encouraged. Thanks for letting me be free to be me. Thanks for your faith and trust in me as a "godly woman" and a "world class educator."

Mom, I must single you out for sharing your "widow's mite" with me. It sure helped me to make some of those very needed trips abroad. Thanks from the bottom of my heart.

Contents

With Appreciation

January 31, 1999

Dear Dr. Eva,

"Gratitude is the truest sentiment imbedded in my heart."

Words are inadequate to describe the feeling that enveloped and enthralled me as I read through your foreword for my first book, *Let Justice Flow*. For me, it was the icing on the cake. While I have recorded the "what" of my experiences, you have enlightened and informed us, in a nutshell, with the "why" through a brief, concise, historical perspective of the Black community during my years.

I have a deeper and greater appreciation for the days when you were my high school geography teacher at the Berkeley Institute. I now know that it went beyond acquiring academic knowledge about geography, to your "special responsibility" to prepare young Black children to survive

in a segregated society that was unabashed in having as its primary purpose White domination and White supremacy.

Your labour has not been in vain. I caught the spark of your undying and unwavering commitment and dedication to enlighten and inform your people about the evils of racism. You have been my shining example and my constant source of encouragement in my struggle for freedom, justice, and equality in our native land.

A very enlightening, informative, candid, straightforward, and very revealing foreword!

Thanks ever so much, Dr. Hodgson.

With deepest appreciation,
Dr. Muriel

Foreword

I feel compelled to declare my vested interest in having every Bermudian, particularly every Black Bermudian, read Dr. Muriel Wade-Smith's account of her professional experience: *Let Justice Flow*. My own professional experience closely mirrors hers; nevertheless, I have striven for objectivity. The reader will decide whether or not I have succeeded.

The author's candor in describing the pain and confusion surrounding the circumstances of her birth not only assures us of the honesty of the rest of her story, but it provides us with the first reason that every Bermudian—particularly every Black Bermudian—should read this account of her personal journey. Unwed mothers and unknown fathers have been an integral part of the Black experience since the days of slavery. Each experience may be unique, but those Bermudians who do share some aspect of the circumstance of her birth in one way or another will be reminded that there are others who share their pain and con-

fusion. Those who do not empathize in these experiences, or who do not sympathize with them, will gain insight that should both increase their sensitivity and their awareness of the worth, value, and humanity of those who do.

The author's personal observations of the government-sponsored, segregated school system will bring back memories for many. Although there are formerly "Black" schools, which are still more segregated than integrated, there can be no doubt that the kind of commitment and dedication that Muriel found in the Black teachers of her day were qualities that grew out of an awareness on their part that they had a special responsibility. It was a responsibility to prepare young Black children to survive in a segregated society, which was unabashed in having as its primary purpose continued White domination and White supremacy. This could only be maintained by the demeaning of those in the Black community. There is no question that Black teachers, their students, and the parents of those students held a deep conviction that education would rescue them from the worst aspects of the degradation meted out to Blacks by a racist and segregated society.

The author describes how she began with a one-year teaching certificate but quickly followed it with the primary specialist certificate. It was soon after this that she learned that while some people had their professional achievements recognized immediately by government authorities, many Blacks, regardless of their academic honours and scholarly achievements, had to defend and prove their expertise and worth. In order to have a value placed on her certificates, the author had to take additional courses in Canada. She describes her embarrassment to find that the person who was teaching the programme had only the quali-

fications that she herself had. She wonders why it was that in Bermuda her certificate, the certificate of a Black woman, had so little value, while in Canada the same certificate gave sufficient professional status that the certificate holder could teach what amounted to graduate courses. Courses that she could have taught, she was being obliged to take, in order to gain appropriate recognition of what she had already accomplished. She was just one of those Black Bermudians who were denied the opportunity to grow by being given professional responsibilities. Their growth was stunted by having to spend their energies trying to prove that what they have already acquired is worthy of being shared.

She describes how at great sacrifice to both herself and her family she acquired her B.S. in 1971, which was soon followed by a M.Ed. In 1978 she earned her Ph.D. in educational administration, with an emphasis on curriculum and supervision. Three years later her disillusionment set in because of her idealistic expectations of justice that was not forthcoming from Black decision makers. The expectations surpassed the reality. She had kept the Ministry and the Department informed of her progress toward a doctorate in education, and Dr. Kenneth Robinson had written glowing references of encouragement. She describes how in a TV interview she had expressed a desire to share her recently gained expertise in curriculum with her country, particularly since she was a pioneer in Bermuda in the field of curriculum development.

When the author returned to Bermuda in September 1978 with a doctorate in educational administration, with an emphasis on curriculum, she discovered that two months earlier two appointments had been made of assistant education officers for Curriculum Development. The author

writes, "What was most crushing was the fact that the persons in these new positions had not been involved in any further courses or practical experience in curriculum development and supervision." Muriel Wade-Smith, besides having taught for many years in Bermuda's educational system, had also received the highest academic qualification: a Ph.D. Earning a Ph.D. was rare enough at the time, but it was also in a field that was new to Bermuda but badly needed. The Ministry had sent her information about classroom teaching vacancies, for which she would have needed no more qualifications than she had had when she left here. They had given her no information about the new positions for which her doctorate would have more appropriately qualified her.

At this time, the author goes into great personal detail of her experiences, which some readers may find tedious and wish to skip. *Let Justice Flow* should be read. Muriel Wade-Smith's experiences are not merely personal and anecdotal, they represent the manner in which Blacks concerning others in the Black community were making decisions. How was their behaviour any different from that of Whites practicing racism? The White community had routinely and unabashedly appointed less-qualified Whites rather than some more-qualified Blacks. Black decision makers were now doing the same thing. It was certainly more personal, because the reasons for this discrimination were more personal. This rejection by those Blacks making the decisions at this period in Bermuda's history was a stinging form of abuse to this hard-working, certified, and qualified educator. None of those in the Ministry making the decisions concerning the author's professional career had a doctorate in anything. Did the higher qualifications of this

obviously ambitious Black woman prove a threat to them? Not only was it painful that Dr. Muriel Wade-Smith's application was turned down, but a direct slap in the face by professionals who had, like her, been forced to struggle through an era of fierce inequalities and separation. This episode felt worse than rejection. It was a kind of excommunication. Wade-Smith was so angry and hurt that all of her hard work and self-denial seemed to mean nothing that she refused an offer of becoming a reading teacher, even though she had qualifications in reading.

The author's experiences and her response to them must be seen as against the background of the Black experience generally. Some Blacks have challenged institutional racism, and the abuse of power that undergirds it, as well as the indignities that it inflicts on us. Some Blacks have made compromises. Those who have compromised have sometimes done well for themselves individually, but it has been those who challenged the system that have made progress for the entire community. Kingsley Tweed and Roosevelt Brown challenged the system and changed the condition of our lives, but Kingsley Tweed was driven outside of Bermuda while Dr. Brown was forced to earn a livelihood outside of Bermuda. Whether we challenge or compromise is probably preordained by our individual and personal values. Muriel challenged the system and paid the price.

At a time when education was not free, every one in the Black community believed in the value of a good education, even though only a few could make the kind of sacrifices that were essential to be able to afford the kind of education they saw as ideal. The value the Black community placed on education was reflected in the determination, the commitment, the sacrifice, and the hard work that

the author was prepared to invest in the pursuit of her educational goals and despite the obstacles and frustrations she met on the way. The values of the author grew out of the values of a segregated Black community. Muriel Wade-Smith expresses those values when she wrote, "All I had done was adhered to the advice and followed the examples of my sterling, thoroughbred Bermudian and West Indian teachers, who had not only instilled in me the desire to learn, but had also impressed upon me the importance of aspiring to the highest heights in any endeavour that I undertook." In order to reach those heights she wrote, "My family and I endured tremendous sacrifices." It was because the late Dr. Kenneth Robinson held the same values—and he and his family had made some of the same sacrifices in order for him to achieve the same heights, as he worked to acquire his own doctorate—that he could encourage her as he did. By this time, Dr. Robinson was not one of those at the helm. There was a new Pharaoh who knew not Joseph—or Muriel!

Of course, those in the Ministry of Education did know the author. The letters, both business and personal, that were exchanged between her and members in the Ministry of Education verify that close relationship. But with the erosion of government-sponsored segregation there had also come an even greater erosion of the values that had sustained the Black community and made them a gracious people despite the abuse of power inflicted on them by institutional racism. It would be a while before the author understood the change. She, as a Black person, was not alone in the frustration and great indignation she felt at the treatment being inflicted on her by other Blacks.

While education would continue to have some importance, it was no longer the criteria for the success of Blacks. Blacks, at this point in Bermuda's history, had to earn certification from recognized institutions of higher education outside Bermuda; then, upon their return, meet the approval of the White power structure in Bermuda. The single-minded struggle for the goal of social justice was replaced by compromise for the individual social status and personal integration with Whites. Respect for the example-setting older generation and their values was replaced by respect for a very individualistic younger generation and their much higher salaries. For the upward-mobile Black the sense of community, common purpose, and pride in the success of their fellowmen was no longer a priority. Individualism and competitiveness existed among Blacks. The abuse of power that had undergirded institutional racism now became the mark of those decision-making Blacks with power over other Blacks.

Despite her humiliation, frustration and indignation, Muriel Wade-Smith, like the Black community with whom I have compared her, made a significant contribution to her community. Where would this country be without the contribution of the Black community? There are students out there who feel the same way about the author. Wade-Smith, for a number of years, taught a Christian curriculum in a private capacity, which she does not discuss. Having applied for a position at Bermuda College in 1982 that was given to a far less qualified White male, she did not apply for another position until 1991, then she applied for several in 1996, 1997, and 1998. In almost every case, the positions went to less-qualified males or foreigners. In at least one instance, the nepotism was evident. Legislation

calls for advertising vacancies. It is a part of our society's corruption and hypocrisy that is taken for granted that very often decisions about the candidates have been made before the advertisements even appear. Superior qualifications or even ability are then irrelevant.

It was not until 1998 that the author began to see her personal experience in terms of the broader society. She emphasizes her perceptions of the evil of colonialism and racism. The root of much of the evil was certainly in racism. But Black decision makers and the upward-mobile Blacks who have experienced racism have to take responsibility for their own abuse of power and the corruption that it engendered that went beyond racism. They, as trendsetters and role models within the Black community, have to accept their responsibility in the progressive deterioration of the Black community and the consequent physical violence that has followed. The author does name names, and many Bermudians will have had their own experience with those she names, although they would never have the courage to report publicly on their personal observations as she has done. Those named may still wield power to hurt or destroy. The author ends her dissertation on a note of optimism and hope. The reader needs to find out the details of this hope. Young and old need to read *Let Justice Flow* so that they will get some understanding of how this shift of values in the Black community has been so disastrous for all of us. It has been disastrous first for the Black community and ultimately for the White community as well.

A people who were once determined to achieve excellence by their own efforts, sacrifice, and self-denial now have among them those who have become sycophants, dependent on others for their success. Compromise, denial,

and even hypocrisy are the tools of upward mobility, rather than just excellence in education. Success is no longer to be earned by hard work and personal sacrifice. It is to be bestowed by patronage for being an approved "nice" Black person. W. L. Tucker, the father of our Franchise, once expressed disgust at what he called "grinning Negroes." Unfortunately, for those in the Black community—particularly Black women not regarded as nice, or not regarded as sufficiently accommodating, and who did not acquire the social skill of "grinning" appropriately—were likely to be devalued and even destroyed professionally, not only by Whites, but also by decision-making Blacks. They are regarded as troublemakers, regardless of their qualifications, contributions, or potential for contribution.

All Bermudians, particularly Black Bermudians, should read this very personal account, despite—or because of—their lack of awareness of the extent to which our society has changed and our basic values have been eroded. They need to ask, How would our society be different if our decision makers, including our Black decision makers, were to behave as the author assumed that they would? How would your personal experience and those around you be different? Would there be as much anger and violence among the less powerful and the alienated in the Black community if there was more integrity and justice among the more powerful, the decision makers within the Black community?

Dr. Eva Hodgson
Author, Educator, and Historian

Prologue

In the summer of 1995, I traveled to St. Kitts in the Caribbean. While there, my money was stolen. Consequently, I cut my visit short and went to spend a week in New York with a very dear and precious school friend of mine, Ilene. She had decided to go to Rochester, New York, to visit her relatives.

What perfect timing! It was Woman's Restoration Weekend, and Ilene and I attended a prayer breakfast on Saturday and Woman's Day services on Sunday. While there, the evangelist looked me dead in the eye as she pointed her finger at me and said, "Dr. Wade-Smith, it is restoration time in your life. God is going to restore all that the cankerworm has destroyed, and that sevenfold."

I was completely stunned. At the time, it seemed like the impossible of the most impossible. Three years down the road now, I am beginning to see God's restorative power working in my life "exceeding and abundantly above all I could ask or think."

Yes, there have been many times when I've felt disillusioned, discouraged, defeated, and disappointed. Yes, there have been times when I've felt like my life has been such a failure. I've even been called an educated fool. To some, I have been regarded as an investment turned sour. Oft times I have been treated as if I had the plague; I've also been made to feel as though I were the scum of the earth.

I remember, in my presumptuousness, I pointed my finger at God and said, "God, why in the world did You ever let me get a doctorate? I've never been used in the area for which I am qualified—curriculum. I feel so useless. I feel like I've just wasted my time. Why in the world am I on this earth? Nothing has worked out for me. Why, everything I've touched in my country has failed. Even Christian education, the vision You gave me, has ended up in the hands of a cult church."

How does God turn my moaning, groaning, and complaining into the wondrous works of His almighty hand? The year 1998 started the restoration process for me. For twenty years, I had suffered insults, injustices, and indignities as I had tried to secure employment in my native land. It was only after I came face to face with the evil roots of my country's problems—institutionalized racism and colonialism—that God provided one of the most exciting opportunities of my life.

From January until June of that year, I worked as the Director of Curriculum Revision with Dr. Donald Howard, the Founder and Director of School of Tomorrow, in Dallas, Texas. Under Dr. Howard's leadership, the staff of School of Tomorrow grew from 3 to 350 in twenty-seven years. Over seven thousand schools in 110 countries around the world have successfully used this innovative, individual-

ized, diagnostically prescribed, mastery-level curriculum, implementing a program laced with character-building traits.

Just when I had reached the zenith of curriculum development and was feeling that after twenty years I was finally working in the area for which I was qualified, the rug was pulled from under my feet. My youngest son was killed in a road accident.

How God has used my son's death to help me understand more clearly His purpose for my life is miraculous and beyond my wildest imagination. God has reminded me of my unrighteous decree, in which I told Him that I was prepared to go to hell unless He proved to me that He is a God of freedom, a God of justice, and a God of equality. What surprising and shocking revelations! Such unexpected events!

I have also been reminded of the message entitled "Preference or Conviction" given by Dr. David Gibbs, founder of the Christian Law Association. In his address, Dr. Gibbs stated that Christian education is not a preference, but a conviction. He added that when it is a conviction, none of the following will stop us from fulfilling it: family, friends, threat of lawsuit, jail, money, even death!

Little did I realize that it would be the death of my youngest son that would cause me to fulfill my dream of Christian education in my country. In the process, God has used my life to show that He is a God of freedom, a God of justice, and a God of equality, as He lets justice flow in the most unusual and extraordinary ways.

My sincere prayer is that God will use this book to encourage Christians to be fearless as they make bold and courageous stands for truth and right. May we as Chris-

tians see the pressing need of paying the price—at all costs—
to do God's work. I also want the hearts of my readers to be
touched by one of life's most valuable lessons taught to me
by my son Ashanti: Love causes us to forgive until there is
no more pain; then comes the peace.

Hopefully, readers will engage in a time of self-exami-
nation and ask, "What can I do to tear down the walls of
institutionalized racism and colonialism?" May our hearts
be so touched and moved that we commit ourselves to do
whatever it takes to help dismantle the walls of institution-
alized racism and colonialism and bring about a racially
just and pluralistic society.

Chapter 1

What's in a Name?

And ye shall know the truth and the truth shall set you free. (John 8:32)

NO HEIFFER, NO COW!

"You can't take the cow and not the heifer!" Those were the words that were spoken to me shortly after I arrived at my new extended family's home environment in Friswell's Hill. Mrs. Delphine Augustus—an elderly West Indian lady with soft, braided, white hair—told me that my maternal grandmother, Mrs. Alice Wade, had spoken those same words to her.

What did that all mean? After all, I was only a little girl about seven years old. Those words, however, always stuck with me and caused me many hours of worry as I tried to figure out what they meant.

Everything had happened so quickly. I remember I was sitting in my classroom; it was just before lunchtime. Laughter and happy voices chattering suddenly distracted my attention. Imagine my surprise as I looked out the window

and saw Mr. Richard Augustus walking past my school with my mother and a few other of my family members—and all of them well dressed. What was going on? I was taken aback.

For the remainder of the day, I felt uneasy. I couldn't concentrate. I felt a quivering in my stomach. This was certainly one of the longest days in my life. When would school end? Why wouldn't that bell hurry up and ring so I could race home and find out what was going on? After school that day, I walked quickly ahead of my school-aged uncles and cousins.

What a shocking surprise greeted me as I opened the gate to my house! Right before my eyes, in the center of the yard, was a beautifully decorated table with a stiff-starched, white lace tablecloth, adorned with rice fern and pretty flowers of different colors. More people! Some were standing, while others were sitting, enjoying the festive occasion. This was more than the usual family celebration. There were homemade sandwiches, plain cake, fruit cake, and bottles of strawberry, orange, pineapple, and other flavors of mineral (soda).

I learned that my mother and Richard Augustus had been married that morning. (Strange as it may seem, I have very little or no recollection of Richard Augustus before that time.) Sometime, shortly thereafter, my mother and I went to live with Richard Augustus' family, which consisted of his mother, Mrs. Delphine Augustus; his father, Mr. Charles Augustus; and his sister, Miss Lillian Augustus.

Life proceeded, from the outside, as normal for a shy, little seven-year-old girl. I was registered at Central School. I entered what was called *standard one*. Bermuda, being a British colony, had adopted a British system of education. Central School, an all-Black primary school, was located in what

was called "The Pond"—an area where there were ponds surrounded by grass and reeds. It was a site for trash dumping, and all kinds of dogs seemed to inhabit the area. "Pond dog" had become a familiar expression as a name for anyone who came from that area. Whenever there was a torrential downpour, the playing field at Central became flooded. In fact, they called the school grounds Lake Superior.

Classrooms contained those old, dark brown, wooden desks encased in iron frames with an adjoining seat that could be pushed up when not in use. A round opening for an inkwell was in the top right-hand corner of the desk, and there was an indentation carved out in the center of the desktop for holding a pen or pencil.

The minimum class size was anywhere from thirty-five to forty-five. Classrooms were not tastefully, creatively, or beautifully decorated with self-made or store-bought teaching materials, as many are today. All I can remember is a chalkboard at the front of the room. Those were the days when, before any students arrived at school, a teacher had the day and date written in well-formed letters at the top of the chalkboard. The day's work assignments of arithmetic, writing, and spelling were in separate sections on the chalkboard. Remember, there were no copiers or computers then. As we completed each subject, eager students would volunteer to erase the board so that the next lesson could be put up.

Upon finishing our assignments, the procedure we followed was that of taking our books up to the teacher's desk, standing in line, and waiting for our work to be marked. As I remember my standard-one teacher, she was a kind, caring, compassionate, and gentle teacher. I believe it was because of such an unthreatening atmosphere that I felt free to

share my latest, most wonderful news with her. When it was my turn, I watched very proudly as she ticked my work with her red pencil and wrote "Very Good" at the top of the page.

Seizing the opportune moment, I excitedly said, "My mommy got married."

Everything went dead quiet. Had I said something wrong? The response was not what I had expected. I felt as if ice water had been thrown on the blazing fire that had been burning with excitement in my heart. I had felt happy and had thought I would share my happiness with my teacher. Was I expected to contain such excitement? Why? My mother had gotten married; wasn't it something to be excited about? I now had someone I could call "Daddy." I had new friends and relatives. I even had a new grandmother and grandfather. Something very, very wonderful had happened to me.

As I walked quietly and slowly back to my seat, I felt crushed and wounded. Alas! Reality had reared its head, and I knew that there was something that was not right about being able to say that my mother had gotten married when I was seven years old. What was it?

I discovered the answer through many painful events that occurred during the remainder of my life. I had to seek the answers to some very piercing questions. Who was I? Was I Muriel Wade? Muriel Augustus? What was Richard Augustus to me? Was there some mystery surrounding my birth?

One of the most crushing and damaging events in my young life happened when I was around nine years old. I was at a friend's house, and there were about six of us playing marbles. We were all having lots of fun. Out of the blue, one of my friends said, "You are a bastard! You are illegitimate!"

I felt deflated. It felt as if a dagger had just pierced my heart. *What's a bastard? What's illegitimate?* Just the way she said it, made me feel like the scum of the earth. For some unknown reason, I felt ashamed.

Suddenly, I did not want to play marbles anymore. I picked up my marbles and walked slowly home. Tears flowed down my cheeks. I kicked stones as I tried to keep my mind off what seemed like the most dreadful words anyone would ever hear in her life: *Bastard! Illegitimate! Bastard! Illegitimate! Bastard! Illegitimate! Bastard! Illegitimate!* The echoes of her words mocked and tormented me as I continued walking.

I slipped into the house. I did not want anyone to see me. I went into the bathroom and tried to compose myself. Then I went to my bedroom, flung myself across the bed, and sobbed my poor heart out. After what seemed like hours and hours of heart-wrenching misery, I dried my tears. As I sat up, my eyes focused on a dictionary that was on the shelf. I jumped up, grabbed the book, and quickly flipped the pages until I found the word *illegitimate.* The meaning was "the child of an unmarried woman." How enlightening! Then, I turned back to find the meaning of the word *bastard.* Its meaning was "a child born out of wedlock."

How could someone be so cruel to call a person those names? As I gradually got over the initial shock, I reasoned with my nine-year-old mind, *Why is she calling me those names? What do those names have to do with me? I did not have anything to do with how I was born.* I began to feel anger toward my mother. Why hadn't she told me that I was a bastard? Why hadn't she told me that I was illegitimate? How could she let people call me such dreadful, horrid names?

Now that I knew the truth about the circumstances surrounding my birth, I felt very sad and very uneasy. With whom could I discuss this problem? Everything was hush-hush. Everything was top secret. Little did I realize that I was one of the greatest secrets of the Wade clan. I quickly gathered that the circumstances surrounding my birth were something that was never discussed. It was a forbidden subject.

One day I was walking through the city of Hamilton, the capital city of Bermuda, with my cousin Judy. As we crossed the street, an elderly woman stopped us. It was a friend of the family. After exchanging the usual greetings and inquiring about the family, this well-meaning lady looked at me and asked, "What's your name?"

I respectfully answered, "Muriel."

Then, she proceeded to put me through a series of questions. I believe she was trying to establish my identity. "Whose child are you? Who is your mom?"

I dutifully answered, "Lois Augustus."

"What is your grandmother's name?"

"Alice Wade," I replied.

"Who is your daddy?" she asked as she continued to probe.

I answered sheepishly, "Richard Augustus."

She ended the conversation by saying, "Oh! I didn't know Richard had a big girl like you."

I felt like sinking into the ground. I began to realize that something I had thought was so exciting and so wonderful had another side to it. Was there some dark mystery lurking in the shadows of my past?

Not only did I have to contend with outsiders trying to discover my true identity, but also there were family members who were determined to let other people and me know who I really was.

Richard Augustus, my new daddy, had a sister named Amelda. We called her Aunt Sue. She lived within seeing distance of the Augustus homestead. It usually took us about five minutes to walk to her house, which we called "over the land." Bless her heart, she was the one who marshaled all of her children and all of the relatives' children and took them to Sunday school and church.

One day I was visiting the house of an elderly woman from the church. She was sick, and a group of young people went to sing hymns for her and take a fruit basket to her. What a shock I got when she said to me, "Your Aunt Sue said that Richard Augustus is not your father." I was dumbfounded. I did not know what to say.

On another occasion at a family gathering, one of my aunts said, "Muriel, you mind your stepfather. Do you hear me?" I was confused. What was a stepfather? Once again, I had to get an answer from the dictionary real fast. A stepfather is the second or later husband of one's mother. How could he be my stepfather? This was my mother's first marriage.

There were times when being a bastard or illegitimate did not bother me. Every now and then, something would happen that would cause my little mind to wonder. I needed to figure out this situation. One day, my mother and I were out shopping. We met one of my cousins—my mother's niece. We greeted each other happily.

"Aunt Mottie," she said, smiling, "how are you?"

My mother replied quite excitedly, "Wonderful! Today is my birthday."

"Happy Birthday! Is it the big fifty?"

"Not yet! I have ten more years."

I immediately started to calculate. If my mother was forty and I would be twenty-five on my next birthday, then

by the process of subtraction, I was born to a teenage mother. What a crushing blow!

Shortly after this incident, I needed to renew my passport, which required my birth certificate. The birth certificate clearly indicated that Richard Augustus was my father and that Lois Augustus was my mother. Yes, my birth date was July 13, 1939. There was one thing that really puzzled me, however: the registration date on the birth certificate was August 12, 1951. Once again, through the subtraction process, I established that I must have been twelve years old when my birth registration was filed. After that realization, whenever I passed the registry general's office, I'd think about going up there to verify if Richard Augustus was really my father. But somehow, I would always back off. I was too embarrassed to know the truth at that point. Then I felt a deep sense of compassion for my mother. I felt that there was something that was very painful for her, and rather than hurt her any further, I vowed I would carry this deep secret to my grave.

Time passed. I married. My wedding bans were in the name of Muriel Marie Augustus. Richard Augustus performed his duties as the father of the bride. As best I could, I tried to fulfill my part as the dutiful daughter, but there was always this continuous nagging and gnawing within that would not release me from the pain of not knowing my true identity. I remember that when Richard Augustus suffered a heart attack and died, an elderly Christian woman said to me, "Your Aunt Sue said Richard Augustus was not your father."

I very defiantly yet politely said, "He was the only father I knew."

There were times when I tried to ignore the rejection. I wallowed in denial by saying, "If my real father has rejected

me all of this time, who needs him now? The only thing I would want from him at this point is some money or a house."

Eventually the day came when I had to face the truth. No longer could I live in denial. No longer could I put off being freed from the bondage of not knowing my real father. God used the pastor of a nondenominational, pentecostal church to help me come to grips with the truth. This pastor was the only person in whom I had enough confidence to share my heart. I told him quite frankly that I was fifty years old and I did not know who my real father was and that I had vowed to go to my grave with this secret. He advised me to ask my mother who my father was.

I left his office, determined that under no circumstances would I put my mother under any further pain by opening old wounds. A few days later, however, as I sat quietly at my kitchen counter, eating my breakfast and reminiscing over the directions I had received from the pastor, I heard a small, quiet voice in my heart whisper, "*Call your mother.*"

I took a deep breath. I squirmed in my seat. Slowly I dialed my mother's number. At the same time, I was hoping she would not answer. My heart beat a little faster as I heard her voice at the other end of the line.

After exchanging the usual greetings, the words flew through my quivering lips and out of my mouth before I knew I'd said them: "Mom, several people have told me that Richard Augustus is not my father. Who is my father?"

She paused. I almost sensed a back-against-the-wall feeling coming through the phone. In a very calm and quiet voice, my mother replied, "Meet me for lunch on Saturday, and I will tell you."

Naturally, the next three days were filled with anxiety. What would my mother tell me? Who was my real father?

There were times when I had seen two men befriend my mother. I wondered if one of them was my father. I had mixed feelings about having lunch with my mother on that Saturday. A part of me wanted the day to hurry up and arrive so that I could find out the information that would free me. Then, there was that part of me that was fearful of the unknown. I spent three sleepless nights tossing and turning as I tried to speculate about the contents of my mother's conversation.

Finally, Saturday arrived. My mother and I met in a quaint, old-fashioned restaurant in the center of the city of Hamilton. Over a toasted, whole-wheat, tuna-fish sandwich and a well-brewed, steaming cup of tea, my mother had the painful task of telling me that at the tender age of fourteen, she had been sexually-assaulted by her brother-in-law, who was twice her age. I was the result of that encounter. Consequently, a man whom I had called uncle all of my life was, in actual fact, my father, and a woman whom I had called "aunt" was the wife of my biological father. As I tried to fathom this new revelation, it seemed like I was struck by an exploding bombshell. I now had a sister and three brothers that I had previously known only as my cousins.

Thank God, the truth was out! I had some further questions, and my mother very graciously provided the answers. I thanked my mother for telling me the truth. We finished our lunch and went our separate ways. No one could have prepared me for the information that my mother had just shared with me. No wonder I had felt as if there were some dark mystery lurking in the shadows. I drove by the waterside, and as I looked out on the peaceful ocean, I felt a deep-settled inner peace. As I pondered what my mother had just told me, tears ran down my cheeks.

I thought of all the years I had lived in deception. I did not blame my mother. In fact, my heart was moved with compassion for her. Imagine! She had carried that deep secret for over fifty years. I'm sure that just as I was set free by the truth, my mother was also freed of that heavy, burdensome load.

Sometime later, I went to visit my aunt, the wife of my biological father. It was one of the longest walks of my life. Each step that I took became more difficult. I was fearful of what may be awaiting me at my aunt's house. What would be her response? We exchanged the normal pleasantries. When the opportune moment arrived, I bravely said, "Auntie, my mother told me that your husband was my father." She looked stunned. Then, after catching herself, she shared some very interesting information with me.

"Yes," she answered. "Of course, he denied it. But I knew he was a devil. You only had to live within four walls to know that he was a devil. Your mother was not the only woman he troubled."

By this time, my biological father and uncle had been dead for some time.

My aunt continued, "I was the one who had to take care of him when he was sick. He died of cancer of the throat. There were times when I felt like taking the pillow and smothering him to death. I believe the good Lord would have forgiven me." Then, she added painfully, "All I knew was that my younger sister was carrying my husband's first child. I don't blame your mother; I blame your grandmother. Your mother should have been in school. She was only a little girl—fourteen years old. Your grandmother kept her home to do housework and to make lunches for everybody."

"Did your mother tell you that I took you to church to be christened?"

I answered in the negative.

I asked my aunt, "Have you told your children about this?" She said, "No!"

I thanked her for sharing the information with me and left.

As I thought over the situation, I realized that I was thirty-two years old when my biological father died. By this time, I had been married eight years. I also had a son who was four years old, and I was expecting my second child. This meant that my biological father had missed the wonderful opportunity of developing a relationship with his oldest daughter, his son-in-law, and his grandson.

Several things came to my mind as I pondered over that latest revelation. I thought of all the pain that both my mother and my aunt had experienced. I was totally amazed at their relationship. I remembered the many times my aunt had visited our home. One would have never thought they were involved in such painful, deeply wounding experiences. How had they carried such a burden over the past fifty years? Were they angry? Were they resentful? Were they bitter? Did they feel rejection? How did they cope?

My heart ached for my mother. I felt so sorry that I had not approached her sooner, so that she could have been eased of her pain. I developed a greater appreciation for the manner in which she raised me. I'm sure she had the assistance of all of her family, which consisted of five sisters and three brothers. I remember my mother telling me that one of her sisters, who had nine children of her own, had wanted to adopt me. What a spirit of caring, compassion, and love!

My heart truly pained for my biological father. I deeply regret that we were not able to develop a relationship. I wonder if it would have been easier on everybody if the truth had come out sooner. Would things have been differ-

ent if my biological father had accepted me and nurtured a relationship with me? Did I look like him? Did he ever cuddle, hug, caress, or kiss me? Did he feel proud of my accomplishments? These are some unanswered questions.

I have an even deeper appreciation for Richard Augustus, who struggled against seemingly insurmountable odds to father me. Even though I was not a blood-line Augustus, my life was heavily influenced by the Augustus family. Charles and Delphine Augustus came to Bermuda from the island of St. Kitts in the Caribbean. They brought with them an entrepreniurial spirit which was invested in their masonry skills and farming activities - raising goats, pigs, cows, chickens and horses. I remember going down to Front Street in Hamilton with them to meet the Lady Boats, ships that ployed between Bermuda and the Caribbean.

My grandparents bought such wares as mangoes, breadfruit, yams, tanyas, ginger, and coconuts. They combined these items with produce from their gardens—bananas, potatoes, tomatoes, carrots, string beans, onions and pumpkin—and sold them in the neighbourhood.

Family life was highly valued and treasured by the Augustus family. There existed a deep sense of community, togetherness and belonging amongst all of the family members. The Augustuses were extremely severe disciplinarians and obedience and respect were not only demanded but also commanded from their older grown children and the younger grandchildren as well.

There was evidence of the "fear of God" in their lives and they modeled such characteristics as honesty, justice, integrity, determination, diligence and perseverance, to name a few. They were firm believers in "an honest day's work for an honest day's pay," and under no circumstances

would they stoop to being the recipients of hand-outs. They also held very stringently to a "pay cash as you go" policy.

With each passing day, the pain, the hurts, and the wounds surrounding my true identity lessened. I reached the place where I did not care who knew I was a bastard or illegitimate. I felt like I could stand on the highest point in Bermuda and tell everybody,

"Yes, I was born to a teenage mother. Yes, I was born illegitimate. Thank God now that I know the circumstances. I am a free woman. It doesn't matter that I have a sister and three brothers that are also my cousins. The truth has set me free."

RENOUNCE THE HIDDEN THINGS OF DISHONESTY

In the midst of this release of freedom, I heard a still, quiet voice admonishing me: "Renounce the hidden things of dishonesty." This was followed by a very strange and unusual event.

"Muriel Wade!" a thunderous voice bellowed. Startled out of my sleep, I raised myself up on the bed. What was happening? Had I heard someone call my name?

As I sank my head quietly back on the pillow, I lay there, gazing at the ceiling, somewhat disturbed and rattled. Quick as a flash, I felt as if I were thrown back in time about forty years. I vividly recalled the day and the only time I can remember being called by that name. Familiar scenes slowly unfolded before me. I was completely overwhelmed by those unusual happenings.

How well do I remember that day! I was a little girl about ten years old. I was walking up Mount Hill to my grandmother's house. As I walked briskly—past tall, stately

cedar trees surrounded by beautiful pink oleander trees swaying in the gentle breeze, and match-me-if-you-can shrubs providing well-coiffured hedges around the white-roofed, pastel-colored houses with their hues of pinks, blues, yellows, and greens—I looked up in the hills and waved to my aunt and uncle, who had called out to me. That was my only recollection of having been called Muriel Wade. Other than that, as far as I could remember, I had been called Muriel Augustus.

That suited me fine. People with surnames beginning with the letter *a* were always first in any group arrangement. Yet, there was this churning deep inside of me that made me feel uneasy about being called Muriel Augustus. Unable to bear the frustration and mystery about my real name any further, I said a very simple yet sincere and earnest prayer: "Lord, I never remember being called by my real name, Muriel Wade.' Within seconds, as I lay there, I saw a picture of an old, deep, purplish navy-blue school register. As my eye traveled to the bottom of the page, listed in bold, neat, legible handwriting was the name "Wade, Muriel Marie." How well do I remember those old school registers of my childhood! They held the records for school attendance. They showed your name, your birth date, and contained ten spaces for the morning and afternoon sessions for each day of the week. I was stunned, and as I tried to fathom what was happening, I heard that still, quiet voice say, "Renounce the hidden things of dishonesty!"

Now I had enough nerve to go to the registry's office. I wanted a copy of my original birth certificate. I informed them that my present birth certificate, even though it was legal and had the red seal of approval affixed, it was not true. The Registrar General produced my original birth registration form, but she also told me that I could not get my

original certificate, because Richard Augustus had signed that he was my father, and as a result, I was considered as being duly legitimized. I was not happy with that new information. I decided to engage the services of a lawyer.

I was adamant about having my true birth certificate. Since Richard Augustus was dead, I had the painful task of going with my mother to a notary. My mother had to swear that the information provided was not true, and she had to produce a sworn statement about the circumstances surrounding my birth. Oh, what a tangled web of deception!

Since I had never been called by my maiden name of Wade, I decided to have my name changed by deed poll. How proud I felt when I said to the lawyer, "Change it to Muriel Wade-Smith." A weight was lifted off my shoulders. Several family members and well-wishers thought I was crazy. Someone suggested that I should let sleeping dogs lie, and someone else became very angry and annoyed with me because they felt I was embarrassing my mother. Interestingly enough, several people came to me and asked about my situation. They related how humiliated and embarrassed they were when they found out who they thought was their father turned out not to be their father. I comforted many people because I had been set free by the truth.

In due course, my lawyer was able to provide two witnesses, my aunt and my uncle, who swore under oath that Richard Augustus was not my father. Then the judge in chambers made the ruling that I could receive my original birth certificate. On this certificate, the name of the father had been left blank.

I am free from the stigma of being illegitimate. I have a deep compassion for children who are born out of wedlock. I also have a special concern for teenage mothers and a de-

sire to encourage them to love and care for their children. In spite of the circumstances surrounding my birth, I always knew my mother loved me and that she cared for me. My mother has become my best friend. She has always stood by me. In my books, she is one of the world's greatest heroes. In her own way, she has been a martyr. She, by her life, has shown me such an indomitable, conquering spirit in a very gentle manner. I thank her for giving me life and for nurturing and nourishing me to become the person I am today. I know she made tremendous sacrifices on my behalf. I truly love her, and I wouldn't be where I am today if it were not for her. Someone has said, "It's not how you get here, it is what you do after you get here that really counts."

My greatest joy and happiness was in finding out the truth. I know my real father and my real name. I proudly sign my name Dr. Muriel M. Wade-Smith. I paid a costly price to learn the truth about my illegitimate birth. What a difference this truth has made in my life!

Chapter 2

Don't Segregate Me!

For precept must be upon precept, precept upon precept; line upon line, line upon line, line upon line; here a little, and there a little. (Isaiah 28:10)

PRIMARY SCHOOLING

Central School, now called the Victor F. Scott Primary School, was the institution where I received my primary education. It was situated in one of the most deprived areas of Bermuda. When I attended Central School, it was an all-Black primary school, and I believe it remains virtually the same today.

In spite of the deplorable, dilapidated, over-crowded, and inferior conditions, learning had the order of the day. Morning assemblies consisted of singing those old, heartfelt, familiar children's songs. Three of my favourites were "Jesus Loves Me This I Know," "Jesus Wants Me For A Sunbeam," and "All Things Bright and Beautiful." This was followed by reciting such well-known Bible passages as the Lord's Prayer, the Ten Commandments, the Beatitudes,

Psalm 23, and Psalm 121. The headmaster gave positive words of encouragement and admonition about character-building traits, such as punctuality, diligence, determination, honesty, and deportment. Then, quietly and orderly, we filed back to our classrooms to complete the day's work. While it was not termed a "Christian school," in those days we were very God-conscious, and that attitude deeply influenced our thoughts, words, and actions.

Discipline was enforced at all costs, and disrespect for teachers was not tolerated in any shape or form. Unruly behavior, loud talking, or talking of any kind for that matter was not permitted. The strap or cane was readily available to assist those pupils who refused to toe the line.

Students were sent to school to learn, and under no circumstances would there be any departure from that position. There was a no-nonsense attitude perpetuated by the sterling, thoroughbred Bermudian and West Indian teachers of those days. Teaching was not a job, yet somehow the teachers of those days seemed to regard teaching as a divine calling. They acted as if they were accountable to God for the lives of children who were entrusted to their care. If children failed to learn, then the teachers felt as if they, too, had failed. The day's task was not complete if each child did not achieve some measure of learning, even if it meant working through the lunch hour and after school.

Dedication and commitment to teaching were the most important criteria for those entering that hallowed profession. Teach for money? Despicable! Never for the reward of money, but for the joy and love of teaching. What was the price for opening up the doors of knowledge to a child? Priceless! How could a teacher be compensated for instilling in children the joy of learning? What was the pay for

making a difference in the life of a child, one of the most precious human resources?

Learning was a joy, and to aspire to be the best in whatever undertaking was indelibly engraved on the hearts of the pupils. Standards of excellence in penmanship, reading, writing, speaking, music, art, and physical education were duly encouraged.

It was in such an atmosphere and attitude for learning that I was inducted. Not only did I perform well, but also I thrived in such an atmosphere. At one point, I was described as "a very bright girl," and I was skipped from standard three to standard five. After a short stint there, however, I was returned to standard three that became standard four; and after a year, I was promoted to standard six. I remember entering that new school year with much fear and trepidation. Would I be successful, or would I have to go back to standard five? I worked hard and continued to perform well, although placed amongst many older students.

During my years at Central, my conscientious and diligent work habits caught the attention of the principal, Mr. Victor F. Scott, a schoolmaster from Jamaica. I was afforded a place in the scholarship class. That class was for a select group of the younger and brighter children. The assembly hall became our classroom for most of the school year. It was there that three to six students were vigorously drilled in arithmetic, mental arithmetic, reading, comprehension, spelling, and general knowledge in preparation for the Bermuda Government Scholarship Examination. To be chosen to be a part of that group was a great honor and a distinct privilege.

The Bermuda Government Scholarship Examination was held each year for all children ages eleven and twelve. It corresponded with the British version of the eleven-plus

examination. The first part of the examination was taken at the Department of Education. Six candidates were chosen from the results obtained in this examination. After that, an oral examination about general knowledge was held. Unfortunately, I placed fifth out of the six candidates. I was, however, awarded a Gibbons Scholarship that was tenable at Berkeley Institute, an all-Black high school. The scholarship was for three years, and all books and fees were provided. At that time, we were living in an era when parents sacrificed and paid for the education of their children.

I remember one of the stern, no-nonsense teachers I had at Central School. She was from Jamaica. Education was a high priority in her life. She made us stand on the bench if we did not answer correctly. She also resorted to name calling if our behavior did not meet her high standards. She hurled some harsh epithets at us. They were just enough to instill fear in our hearts. As students, we realized that we had better learn or we would be insulted. There wasn't any sense in complaining to our parents, because if we were punished at school, and our parents learned about it, we were also punished at home.

The teacher from Jamaica drilled us. We had to sing our multiplication tables every day after lunchtime. She wrote scriptures for us to copy, especially from Proverbs—and believe me, we knew that we'd better write in our best penmanship. I believe that's why I get so many comments about my penmanship today. Every letter had to be formed correctly. Today, when I see some of the penmanship of some students, I cringe. While her method may be frowned upon by many from the teacher-training institutions, I cannot argue with the results. I got a strong, solid, basic educational foundation. That teacher impacted my life tremendously.

In retrospect, Mr. Victor F. Scott, the principal, influenced my life in a very different way. As a young, impressionable girl of ten years, Mr. Scott's gentle and kind manner with his female staff members overwhelmed me. They seemed to feel loved, protected, and at ease in his presence. One day after school, while I was walking along Parson's Road, I met Mr. Scott. He tipped his hat and said, "Good afternoon, lassie." I was impressed. I settled in my mind, *That's the kind of man I want to marry—a gentleman who is willing and prepared to treat me like a lady.*

SECONDARY EDUCATION

I entered Berkeley Institute at the age of twelve. During that time, Berkeley was the most renowned high school where Black children could receive quality education.

I have to admit that I did not diligently apply myself while at the Berkeley Institute. I attribute much of the turmoil in my life and the lack of interest in doing schoolwork to the mystery surrounding the secret attached to not knowing my biological father. At one time, I was referred to as "a disgruntled student." That was when I decided not to follow the more academic course aimed at the Cambridge School Certificate Examination and opted for what I thought was an easier commercial course. I eventually reverted to the academic track.

In those days, we did not have school counselors at our disposal. We either performed or didn't perform. If we didn't perform, and our parents didn't have money, we became a dropout and fell by the wayside. Remember, Blacks were separated from Whites. There was, however, clear evidence of class distinction among Blacks. Fairer-skinned children

were afforded privileges and favors not granted to blacker or darker children. There was also discrimination against children of West Indian parentage. Children from Friswell's Hill, Parson's Road, Pond Hill, and Smith's Hill were regarded as being of lesser social status than those from certain parts of West Pembroke, Crawl in Hamilton Parish, and South Shore in Smith's Parish. Who our parents were and our religious affiliation also seemed to have some bearing as to whether we were accepted or not.

My teenage years were extremely difficult. My young mother—twenty-six years old and only fifteen years older than I—must have had many troubled times keeping me focused and on track. This was further complicated by being married to an alcoholic man whom I called "Daddy." Confusion beset my path.

Eventually, I persevered. I returned to the academic stream for an additional year and was successful in obtaining a third-grade certificate in the London Overseas Cambridge School Certificate.

Looking back, I have some fond and precious memories of my time at Berkeley Institute. It was the most reputable school for preparing Blacks to take their rightful place in society. Several teachers at that institution influenced my life.

Mr. Frederick Furbert and Mr. Neville Tatem, the principal and assistant principal respectively, were Christian men who were affiliated with the Gospel Hall or Brethren denomination. They were instrumental in touching children's lives for eternity.

Every morning, those two faithful servants challenged our hearts. Our assemblies started with faith-building songs from the old, red, Church of England hymnbook. If I re-

member correctly, we were required to buy that hymnal just like a textbook. The lyrics of some of the songs, such as, "Fight the good fight with all your might / Christ is your strength and Christ your right / Lay hold on life and it shall be / Thy joy and crown eternally," and, "Lead kindly light amid the encircling gloom / Lead thou me on / The night is dark and I am far from home / Lead thou me on," became the favorites of the staff and students. Simple, heartfelt prayers by Mr. Furbert and Mr. Tatem followed the singing. A short discourse based on the Word of God was usually given to the staff and student body.

During my high-school years, several Black preachers and people who had attained distinction in various fields were invited to address the student body. Oft times, American preachers from the African Methodist Church—spiritual leaders deeply entrenched in the Civil Rights movement in the fifties—would challenge our student body to become involved in the struggle for equality and justice for Blacks.

Something that had a profound effect on my life was the positive role model that my teachers were for me. For the most part, they demonstrated to us high moral and ethical standards. Many of my teachers had traveled abroad to prepare themselves to be on the faculty of the Berkeley Institute. I gathered that it was quite an honor and an accomplishment to be a part of that faculty. Some of my teachers had traveled to England, Canada, America, and the Caribbean for further study.

Somewhere, in my mind, their accomplishments made me ask the question, *Will I ever be able to go abroad to further my studies and prepare myself to be a teacher?* Let me share a few thoughts about some of the teachers who influenced my life.

Mrs. Beryl Manget taught literature during my last year in high school. She was always immaculately dressed and well groomed. If there was anyone who was in command of "the queen's English," it was she. I especially enjoyed her thorough and interesting presentation of *Northanger Abbey*. I believe her literature classes encouraged me to want to further develop my skills in writing. She made book characters come alive, and I found her classes most exciting.

Mrs. Veronica Ross was a very godly, compassionate, gentle, and soft-spoken woman. I was simply intrigued by her thorough explanations during my religious-knowledge classes. How can I forget the lesson she taught about the disciples plucking corn on the Sabbath day! The practical application of that lesson has stuck with me up until today. It was this: In times of necessity, the spirit of the law overrules the letter of the law.

Mrs. Elizabeth Kawaley taught me French. She made the lessons so interesting, and students wanted to do well in her subject. She went beyond the call of duty to make sure we understood the lessons. I remember being particularly excited about participating in a French play that our class presented to the student body. I also remember walking through the streets of Hamilton with some friends of mine; our rule for those outings were that we had to speak French all the time. All of us did quite well in the subject, and I venture to guess that it was this self-designed, extracurricular activity that was the reason for our success.

One teacher, an American named Mary Rose Allen, taught physical education. She was a very stately, robust, and elegant woman of stature. She walked with dignity. She held her head high and conveyed to us by her deportment that under no circumstances were we to feel inferior.

Dr. Eva Hodgson taught geography. She appeared to have a deep passion and love for this subject. Forty years down the road, I realize that not only did she have such a passion for geography, but she also was prodded by a compelling and burning desire to educate her people, so that they would be freed from mental enslavement, mental bondage, and mental oppression. Oft times in the midst of our lessons on mountains, valleys, oxbow lakes, the Caribbean Islands, the continent of Africa, or any other aspect of world geography, she managed to slip in an important lesson about freedom, justice, and equality for the Black person.

Merle Brock-Swan-Williams was not the traditional kind of teacher. In fact, I regard her as my mentor. She was an innovator and fought valiantly for alternative education for Bermuda's children. She was a pioneer in the field of alternative education. She came alongside children who were the outcasts and rejects of the system, made them objects of her love, and helped them to achieve after they had been thrown on the proverbial trash heap. She defied the authorities at the expense of meeting the needs of the students.

On February 6, 1997, I wrote a tribute to my mentor, Mrs. Merle Brock-Swan-Williams. I believe what I felt about her encapsulates my feelings for all of those wonderful teachers who made a difference in my life. I share it with you here:

WHY I APPRECIATE MERLE

Why do I appreciate Merle Brock-Swan-Williams? I believe the most important reason is because she was one of those sterling, thoroughbred, committed, and dedicated teachers, that not only impacted my life, but also had a tremendous influence in shaping and molding my life.

How did I come to know Merle? It was when I was twelve years old and had been awarded a Gibbons Scholarship to attend Bermuda's most prestigious and prominent high school, the Berkeley Institute. Merle was our English teacher, but as I look back, I am most grateful for the life lessons she taught me.

As an English teacher, Merle had the English language at her command. She challenged us to be grammatically correct at all times. Not only did we have to write "the Queen's English" correctly, but we also had to speak it correctly and distinctly. There were no letups. She demanded high standards of excellence. Essays, more essays, and more and more essays were required of her students. "I don't know what to write" could never be uttered from our lips. The only choice we had, with respect to our assignments, was being certain they were of outstanding quality. Guess what? Whenever we handed in mediocre work, we knew it, and Merle dealt with us quite firmly. She would remark, "Pray, tell me, where do you think you are going with this trash?"

During those days, we were not fortunate, or unfortunate, enough to have substitute teachers. Oft times the secretary would come and tell us that a teacher is sick and that we were to study quietly. Did we relish those occasions? But you know what happened! Can thirty precocious teenage boys and girls remain studious for forty minutes? Alas, the first ten minutes would go well; one could've heard a pin drop. Then somebody would decide to break the silence, and nearly everybody would enjoy some well-deserved freedom, so we thought.

You guessed it! Merle would hear the raucous. She would come flying into our classroom, and the dressing-down she gave us would keep us quiet for almost a month. Of course, the whole class had to stay in detention.

Some young lady sashayed into the classroom while Merle was setting us straight.

"Where have you been?" Merle inquired sternly.

The poor girl was frightened and astonished. She quickly tried to hide the comb and brush behind her back. She was, however, too slow for Merle's sharp eyes. Merle pointed her finger at the young lady and said, "I've told you to stop all of this primping. Looking like *Vogue* on the outside and vague on the inside." Of course, all the students burst out laughing. Merle quieted us down quickly by letting us know that some of us weren't any better.

I remember the time when we were scheduled to have Merle for English. We waited and waited. We were too scared to make any noise, because we did not want another detention and more lectures. By now, we had learned our lesson. About fifteen minutes into the class period, Merle breathlessly rushed into the room. She said, "Now, ladies and gentlemen, I have to go home. I've just come from Mr. Furbert's office. I told him I have to go home. I feel a poem coming on." She continued, "Please, I beg you, don't make any noise. When these feelings strike me, I've got to write. I need your cooperation."

Believe me, we kept quiet the whole period. How come? We were so proud of Merle. Our teacher was a poet. We had a real poet for a teacher.

Merle created a poem. It was called "Ode to Spring." She presented it during the school's May festival. As she recited, our hearts were pumped up with pride. She looked the picture of elegance, dignity, and sophistication. We shared in her success, and we felt that even though our part—merely keeping quiet—had been a small one, Merle's success was our success as well.

Merle's life is not the ordinary, run-of-the-mill, usual life. While many of her teaching comrades have retired and have opted for a life as far removed from teaching as possible, Merle is still championing the cause for the "rejects of the system," touching and making a difference in their lives.

On one occasion, a student had gone home and had reported, "All Miss Brock does is talk to us, and we never get our work done."

Merle's response to the parent was this: "What I tell your daughter can never be found in any textbook. But I assure you that when I am finished talking to my students, they are supposed to be so motivated that they'll go home and complete the work without anyone having to tell them what to do."

Why does Merle continue to do this? She said, "I love children. I love teaching. I don't want to lose any of them." She is one of those teachers who has God's call upon her life, and she wants to touch children's lives for eternity. No amount of money could pay Merle for what she does. She is not like some of her comrades, who have left the teaching profession for more lucrative jobs—to the detriment of our children. Born teachers don't quit. They teach until the day they die.

Money has never been the criteria in Merle's life for teaching young people. She desperately wants children and young people to enjoy learning and to escape the dangers and pitfalls of this evil world.

Merle, I wholeheartedly support you, the pioneer of alternative education in this country. What I do is a small price for what you have done for me. You instill in me the joy of learning. You are my hero. Like the songwriter says,

"You are the wind beneath my wings." I will do all I can to help you.

Love, MURIEL

While I readily admit that my primary schooling and secondary education received in Bermuda provided me with a strong, basic educational foundation, there were some serious shortcomings in my schooling. I firmly believe that because I attended an all-Black high school in the fifties, which was part of a separate and inferior system, there was the underlying feeling that we were in a struggle, and in order to achieve we had to learn. My teachers instilled in me the importance of learning. Education took top priority in our lives. While we may have been placed in separate and unequal facilities, and while we may not have been blessed with the endowments and financial contributions in the same way as the White schools, Central School and the Berkeley Institute have produced outstanding citizens of high, moral fiber and integrity who have risen to prominent positions in Bermudian society in various fields of endeavor.

Under no circumstances did we feel inferior. We knew we were Black, and it was instilled in us that the color of our skin should not deter us from achieving our life's goals and aspirations. We were taught to aim for the highest qualifications in our field and to fully qualify ourselves so that we could be chosen on the basis of our merits. We were taught that hard work brings about success. As Black students, we were fully aware of the Black race's struggle for freedom, justice, and equality. We lived in the era when the movie theatres, restaurants, beaches, sports activities, national army, charitable organizations, clubs, hotels, and even churches were segregated. When I left high school, I applied for a job

I saw in the daily newspaper; it was for a receptionist. I remember the owner of the employment agency, who was a White foreigner, telling me she could not send me there. She did, however, have a job for me as a cleaning woman in a rich, White district. Where had she gotten the idea that I wanted to clean White people's houses? I had helped my mother do that kind of work during my summer holidays, and I vowed that I would do my school lessons so I would not have to clean White people's houses.

The saddest part of my schooling in Bermuda was the aching and empty void that was left because I was not taught about the history of my people. This deficiency still exists today. I think it is a very serious omission. We learned about Elizabeth's policy after the Armada, the Magna Carta, Drake's voyage around the world, and all of the European and British history. Yet we learned nothing about Blacks and their origin, history, and achievements. What a damaging psychological effect that had on us as a people! How cruel, harmful, and injurious this is to my people! Someone has said that if you don't know where you have come from, how are you to know where you are going? Hopefully, in the not-too-distant future, a Black-studies curriculum will be implemented in Bermuda's schools to help alleviate this evil that has made Black Bermudians feel as if they have not contributed to the growth and development of Bermuda, their homeland.

Chapter 3

Second-Class Practices!
First-Class Teacher!

And to some He gave apostles, prophets, *teachers* and evangelists. (1 Cor. 12:28, emphasis added)

TEACHER TRAINING

From an early age, I wanted to be a teacher. I was often seen teaching my dolls and my classmates. At the end of my high-school education, because I loved mathematics, I thought about working as a teller in one of the banks. However, Whites and Portuguese held those jobs exclusively. In fact, the only career opportunities for Black Bermudian women were those of maid, teacher, and nurse.

After successfully completing the Cambridge School certificate examination, I was appointed as a temporary monitor at my former primary school, Central School. Then I was appointed to the staff at the Old Elliott School on Jubilee Road in Devonshire. It was there that I saw the miracle of reading, taught to five-year-old students through the phonetic approach. That experience helped me to decide to teach younger children.

After a year, I applied for a Bermuda government teacher-training scholarship. Prospective teachers could go to Canada or England. One education officer tried to encourage me to go to England. That country seemed so far away and distant. I opted to go to Ottawa Teachers' College in Ottawa, Ontario.

In times past, most Black Bermudian teachers went to Shortwood Training College in Jamaica. Then the Bermuda government made arrangements for a two-year, teacher-training program in Canada for its future teachers. Since my parents did not have the finances to send me to college, it was my only option to receive further study opportunity. Many affluent Blacks went to America and Canada and pursued a degree program. It is my understanding that many Whites also went to America and Canada to obtain a degree, and in most instances, journeyed to England for teacher training.

While obtaining a two-year certificate was, in my thinking, a second-class practice, I am grateful for the thorough, practical training I received in Ottawa and Toronto. I was enrolled in the one-year, teacher-training program in Ottawa. We were immediately thrown into practical, classroom teaching situations. That started in September with a five-week orientation period. One morning a week was devoted to observation in a classroom by exemplary practice teachers. Then I taught one lesson once a week. My practical experience was further strengthened by four, two-week periods of practice teaching in classrooms at four different grade levels.

My time in Ottawa, the capital of Canada, was a very unusual, enlightening, and informative experience for me. It was my first real encounter with White people on a daily basis since I came from Bermuda, where Blacks and Whites

lived in their separate worlds. Remember, that was in the fifties. For some White people, it was the first time they had seen a Black person. I remember walking down the street in Ottawa and hearing two little girls laugh and say, "Mommy, look at that chocolate lady." Even intelligent Canadians used to ask me if I had lived in a grass hut and whether I had worn grass skirts. They even wanted me to speak to them in my native language. My hair was a real mystery to them. It could be straight like theirs, yet when it was washed, it was curly and nappy.

This was also my first experience with cold, frigid winters, with tramping around Ottawa in the snow! I also felt alienated by cultural boundaries and experienced subtle acts of racism. In spite of all of this, I managed to get through my first year. I was homesick every weekend and would have given anything to have been able to put my feet under my mother's table on a Sunday and to have enjoyed my favorite meal of roasted leg of lamb, fresh carrots, paw-paw casserole, and rice with gravy.

What was next on my agenda after obtaining the one-year, teacher-training certificate? I could return home and teach. I could return to Toronto, Ontario, and take the primary-specialist certificate course. I could start working on my bachelor's degree. I was advised to apply for admission to Mount Allison University in New Brunswick. Even though I had the required five credits for admission, my application was rejected because I'd had a third-grade Cambridge School certificate. So, I decided to take the primary-specialist certificate course in Toronto.

The primary-specialist course was a concentrated induction in the methodology and practical training for children between the ages of three and eight years old. I gained the competencies, skills, and experience during this year to feel

extremely confident about working with younger children. Early childhood education became an area of education that I found really challenging and rewarding. I returned to Bermuda and taught in various primary schools throughout the island. Some people remained at one school for their entire teaching career. That was rather difficult for me. After three years at one school, I always found it necessary, for more reasons than one, to move to another school. It seemed like during the first year, I was an observer. Then, as the second year progressed, I became outspoken about things that I felt were in the best interest of the children. After the third year, I believe, people breathed a sigh of relief because I had moved on. I needed that kind of movement to keep focused and stimulated.

After ten years of teaching, stagnation started to set in. There was, however, a strong pull to venture toward the next horizon. In 1968, seven months after the birth of my first son, I shed my wifely and maternal duties and went to Toronto alone. Why? The Department of Education was in the process of recategorizing the Ontario-trained teachers. Teachers in the one-year and two-year trained categories would move up a category if they took two five-week summer courses in Canada.

Imagine my shock and amazement when I entered the classroom in Toronto and saw a former classmate of mine. She was the instructor. Just as amazed as I was, she asked, "Girl, what are you doing here?"

Somewhat annoyed, I managed to reply, "It's my government's way of recategorizing its Ontario-trained teachers."

She said, "I'm embarrassed. You should be teaching the course."

Somehow I endured those five weeks. Weekends were extremely dreadful, for I missed my family terribly. I cried often because of loneliness and homesickness.

The next summer, I took my mother, my younger sister, Pamela, and my son Gareth with me to Toronto. My efforts were rewarded because not only was I recategorized as a three-year trained teacher, but also there was a substantial increase in my salary.

In spite of that, there was something that bothered me about the whole recategorization process. I thought, *Something is wrong if someone in Toronto who has the same qualifications and training as I have can teach a course that I have to take. Is this fair?*

I Want a Degree Too!

What was my alternative? The next category of education for my profession was the bachelor's degree. Shortly afterward, I met an old school friend of mine. She had attended the Berkeley Institute and Ottawa Teachers College. She had also just recently graduated from Miami University in Oxford, Ohio, with a Bachelor of Science degree in elementary education.

I congratulated her. Ernestine accepted the compliments. Then she strongly declared, "Muriel, believe me. It is the next step in your life. Forget that foolishness about American training being inferior to Canadian and British training. You are much brighter than I am. If I made it, you can make it too. Bermuda's elitist system tries to make you think that the degrees are reserved for a certain class of people."

That was just the motivation and stimulation I needed. She encouraged me to follow her example and obtain the degree. She later brought me the Miami University catalog.

How thoughtful and unselfish! I felt challenged now, and wrote to Miami for an application form. Since I had taught in the public school system for more than ten years, I was eligible for secondment. That is a year's study leave with pay. Scoffers tried to discourage me by stating that the preferred place for teachers on secondment was the mother country, England.

What a surprise! I was successful in my application for secondment. I believe that the late Dr. Kenneth Robinson, Bermuda's first Black Chief Education Officer, who had obtained his doctorate from Harvard University, had the foresight and vision to break down the former barriers that had existed, by recommending that I be seconded. I was a pioneer in this area because America was unheard-of territory as a place for secondment for a British-system graduate with Canadian training.

So, with my husband, Oland, and my four-year-old son, Gareth, we set out on an educational adventure to Miami University in Oxford, Ohio. It was another encounter with a predominantly White environment. The first night, my family and I stayed in the loft of a barn that had been converted to a room. I had to get up through the night and go into the owner's house to use the bathroom. I asked myself, *If I'm good enough to use the bathroom, how come I'm not good enough to sleep in the house?* I was highly insulted.

The next day, I went to the foreign students office to see about my living accommodations. Mr. Donald Nelson had arranged for me to stay in Miami Manor. Those were efficiency apartments. After I looked at the place, I knew that my family and I would not be happy in such cramped quarters. I indicated that to Mr. Nelson.

He said, "You can't afford to live off campus."

I asked him where I could find a paper with an off-campus housing listing. He handed me one. Within an hour, my husband and I were back in his office. We had found a two-bedroom apartment at Arrowhead Apartments. It was most accommodating for our needs.

Later that week, I walked over to the president's office. I made an appointment to see the president. I told Dr. Shriver what had happened. I also told him that I had not come to Miami to be insulted by the likes of Mr. Nelson, that I had just met Mr. Nelson, and that he told me I couldn't afford to live off campus. What was he using to come up with such a conclusion? I had just moved out of our new three-bedroom, two-bathroom house in Bermuda, and I refused to live in cramped quarters.

College life placed very heavy demands on me, but I managed to combine the role of wife, mother, and student quite efficiently. My husband, Oland, was extremely supportive and, in fact, worked in severe, blistering weather conditions, with meager pay, in order to remain in Ohio with Gareth and me. We were also very fortunate to have the supportive love of Rev. and Mrs. John Knight, Luther, Sally and Paula Smith, and Paul and Ruth Croft. They became "our families" as they took us under their wings as their friends and children. They made us feel "at home" while we were away from home

College life in America was also quite a learning experience for me. I always felt that obtaining a degree was something far out of my reach. I soon realized that, in America, it was the next step after one completed high school. Degrees were not reserved for the rich and the elite.

I settled in very quickly to the routine of class schedules, midterms, term papers, labs, projects, and final ex-

aminations. Multiple-choice exams! What a difficulty for me! I found I always read too much into the question, and regardless of how hard I tried, I usually could only muster a C or a D grade. Finally, I decided I would take my Cs with courage and my Ds with dignity. In our British system, we were more accustomed to writing essay questions for examinations.

I tried to finish my degree course as soon as possible. One quarter, unbeknownst to my advisor, I took twenty-three hours. I ended up with a 2.8 grade-point average. When confronted by my advisor about the wisdom of carrying such a heavy schedule, I remarked, "I'm not here to get a husband. I have a husband. I'm not obsessed with making the dean's list. While that would be a remarkable achievement, I just want to get through as soon as possible."

My efforts paid off. In December 1971, I received the Bachelor of Science degree in elementary education. Yes, there were times when I felt like giving up. There were times when I asked myself, *Is it really worth all of this sacrifice?* There were times when I got tired of studying. Somehow, I kept the prize before me and persevered.

Beyond that horizon, I saw another horizon beckoning me. *Why stop here? I must forge ahead and work on my master's degree in education.* When I returned home, I experienced some slighting by certain administrators and colleagues. Was it that feeling that an American degree was inferior to a British or Canadian degree? I completely ignored them and combined forces with my dear friend Ernestine. We encouraged several of our teacher colleagues to go to Miami University or another American university to obtain the bachelor's degree. Today, several of those people hold top managerial positions in the field of education.

While in Oxford, I was like a mother hen and conscientiously and diligently looked out for the students from Bermuda. I made numerous trips to the airport to pick up their relatives and friends who were visiting, shared furniture, baby-sat, provided transportation for shopping trips, helped with course schedules, provided textbooks and general information, and assisted with orientation. I became an encourager to my fellow Bermudians.

After three, full summer sessions, I graduated with the Master's of Education for elementary classroom teachers. No turning back now! I was at another horizon. Shortly afterward, I applied to the doctoral program at Miami University. I was accepted and was awarded an associateship. My job responsibilities included Director of the Reading Clinic, Supervisor of Student Teachers, and Assistant to the Director of the Teacher Corps Project in Dayton, Ohio.

My major area of emphasis was curriculum and supervision, and my minor areas of emphasis were elementary school administration and early childhood education. In August 1978, after successfully completing course requirements, writing comprehensive examinations, and defending my dissertation entitled "Identification and Prioritization of Goals for the Bermudan Educational System," I was awarded a Ph.D. in educational administration.

On graduation day, I jokingly said to my youngest son, age five, "Now, you have to call me Dr. Smith."

After playing for a short while, Ashanti returned to the house. He said, "Mommy." Then, he corrected himself and said, "I mean, Dr. Smith." This happened about three times. Finally, in disgust, he sucked his teeth and said, "I'm going to call you Mommy. You were my mommy before you were Dr. Smith."

I hugged him and said, "That's it, Ashanti. Having a doctorate doesn't change me from being your mommy."

Chapter 4

Discrimination
by Exclusion

In every institution, there are three distinct levels at which racism may be operating: attitudes and actions of personnel; policies and practices; structures and foundations. The last is the deepest of the three, for it embodies an institution's purpose and the philosophical basis for its operation.

—Joseph Barndt

THANK YOU, BUT NO, THANK YOU!

It was shortly after I returned to Bermuda in September 1978. I was sitting quietly at my kitchen counter. I was reaching deep within myself, trying to figure out what was going on in my life, when I heard the following acronym:

W—"wait": Be willing to wait on God.
A—"attentive": Be attentive and listen to God's quiet voice.

I—"impatient": Don't be impatient and say, "Lord, please hurry up and give me a job."
T—"time": God has a way and a time for you.

I was faced with the reality of the doors of job opportunities being slammed tightly shut in my face. Here I was, my country's first qualified curriculum coordinator, and during the three years while I was studying, new positions in the area of curriculum had been created and filled. What was most crushing was the fact that the persons in these new positions had not been involved in any further coursework or practical experience in curriculum development or supervision.

It was as if ice water had been thrown in my face. What was happening? Was the system that had produced me now telling me it did not want me in the area for which I qualified? Did it mean anything that I had aspired to the highest heights of education in my career field so that I could return to my homeland and make a very worthy and valuable contribution to the society that had produced me?

I share my findings and interesting discoveries with you. See if you can unearth the reasons for my failure to secure employment in my native land over the past twenty years. After all, I am a Bermudian, and oft times, Bermudians are referred to as "sons and daughters of the soil." Why was this daughter of the soil thwarted in her attempts to make a living in the land of her birth?

In 1975, I took my two sons and returned to Miami University in Oxford, Ohio, to work on the Ph.D. in educational administration. In a letter dated January 3, 1975, Dr. Kenneth E. Robinson, who had been promoted to the position of Chief Education Officer, wrote the following recommendation to Dr. Charles E. Teckman, who was the

chairman of the Department of Educational Leadership at Miami University.

Dear Dr. Teckman,

Mrs. Muriel M. Smith

This is to respond to a request from the above named teacher for a letter of recommendation in connection with her career aspirations.

I am happy to be able to assure you that her aspiration is quite realistic, both in terms of her personal qualities and her professional readiness.

Mrs. Smith is a very highly motivated person who has demonstrated a capacity for overcoming obstacles of remoteness from educational centers, costs, and distractions. I have known her from high-school years and have been repeatedly impressed by her ambition and enterprise.

With respect to her professional readiness, I have intimate knowledge of her professional growth in her classroom activities and success with children and of her pursuit of initial, in-service, and further training.

Mrs. Smith's transcript of work, certificates, and diplomas will indicate her capacity for outstanding achievement; her presence will impress, and I hope, this testimonial will certify and reassure you in connection with her current application.

I wish her continued success.

K. E. Robinson
Chief Education Officer

Dr. Robinson retired and was succeeded by Mr. Sinclair Richards.

In the summer of 1977, I returned to Bermuda and was invited to be a guest on the *Good Morning, Bermuda* television show.

"What are you doing these days?" asked the host of the show.

I informed him that I was working on my doctorate with a major in the area of curriculum and supervision. I also shared with him the responsibilities of being a curriculum coordinator entails.

"What are your intentions when your studies are completed?"

I responded very patriotically by saying, "Bermuda is my country, and I do want to give something back to the society that produced me."

"Is this position, that of curriculum coordinator, presently established in the Department of Education, and do you see yourself working in the Department of Education?"

My simple response was, "Presently, to my knowledge, there aren't any positions of curriculum coordinator established in the Department of Education, but should such a position be established, I would be more than happy to apply for it."

When I had virtually completed all of my coursework for the Ph.D. requirements, I was faced with the task of finding a research problem for my dissertation study. I wanted to conduct a study that would make a significant contribution in helping to improve the Bermudian educational system.

Consequently, in October 1977, I returned to Bermuda and went to see Mr. Sinclair Richards, the recently appointed

Chief Education Officer. I discussed with him the feasibility of using the Bermudian educational system for my research study. Imagine my consternation and indignation when Mr. Richards accused me of having appeared on the local television show and having said that I had been promised a job in the Department of Education when I had completed my degree. He said he had been told this by reliable sources. I include Mr. Richard's letter here.

14 October 1977

Mrs. Muriel M. Smith
714 South Locust Street,
Candlewood Terrace, Apt. #13
Oxford, Ohio 45056
USA

Dear Mrs. Smith,

It has been brought to the attention of the Ministry and Department of Education that you allegedly made public statements (on television) that you will be returning to work in the Department of Education.

Lest there be some misunderstanding as a result of your recent interviews with both the Permanent Secretary and myself, I have been directed to inform you as follows:

Department personnel are chosen by the Public Service Commission who make their recommendations to the Governor.

Interested persons must apply for vacancies as they occur and no guarantees can be given to any individual in advance.

Perhaps there is no cause for concern, but we were disturbed by reports from reliable sources that you spoke

as if you were sure of a position in the Department and it was deemed essential to clarify this matter immediately.
Best regards.

Yours sincerely,

J. S. Richards
Chief Education Officer

CC: The Permanent Secretary

I was highly offended and insulted. In fact, I felt like someone had rammed a knife through the pit of my stomach. I duly responded to the false accusations.

"Ol-Mur Ville"
Hillsdale Estate
Smith's Parish, 3-16
October 20, 1977

Mr. J. S. Richards,
Chief Education Officer
PO Box 1185
Hamilton 5

Dear Sir,

Even though you and I had occasion to interact regarding your letter of the fourteenth in your office yesterday, I find it necessary to respond in writing also.

First of all, let me state very emphatically that, as far as I'm concerned, I could not see any need for such a letter. I, as a teacher in Bermuda's educational system for more than twelve years, am fully cognizant of the procedures involved in the appointment of Department

personnel, and in relation to this I do credit myself with being professionally ethical. Consequently, I would not allow myself to make any statement publicly that was not correct, especially when I had no basis on which to stand.

Second, as a result of the recent interviews with both the Permanent Secretary and yourself, *all* persons involved could state categorically that no such promise of a position was made at any time, and regardless of any information proceeding from supposedly "reliable sources," you nor the Permanent Secretary could be accused of making such a promise; thus, there wasn't any question to answer.

Third, I must say that during the interview alluded to, no mention of returning to work in the Department was made by me. As I recollect, Mr. Winston Jones, the interviewer, did ask me what was I preparing to be. My response to this question was a curriculum coordinator. He then asked what kind of work was entailed when someone assumed responsibilities as a curriculum coordinator. To encapsulate my response to this question, I explicated such things as the curriculum planning process, in-service education, and needs assessment. The interviewer then asked me if I planned to return to Bermuda.

My reply was, "Bermuda is my country, and I do want to serve my country." My one regret at this point is that the interview was not taped so that I would have the necessary evidence to substantiate what I am discussing with you.

I must state that I was a bit concerned that you would react on the information received from "reliable sources," especially since it was told to me that neither you nor the Permanent Secretary saw the interview and that you were not in a position to confirm or deny these allegations aimed at me. I do believe that in all fairness to me, I should have been confronted with the allegations and given the

opportunity to plead innocence or guilt to the charge. If my perceptions serve me correctly, the tone of your letter indicates an agreement with "reliable sources."

While aspirations to work in the Department of Education may be perfectly legitimate, I hasten to add that it has always been my goal to operate in an effective manner regardless of where I am placed.

Thank you very kindly for your attention, and I do hope this letter serves to clarify the matter from my position.

Sincerely,

Muriel M. Smith

Copy to: The Permanent Secretary

Someone asked, "Why didn't you keep quiet? Why did you have to answer that letter? Maybe if you would have kept quiet, you would have gotten a job."

In January 1978, the year I was scheduled to graduate, I adhered to the procedures outlined to me by the former Chief Education Officer, Dr. Kenneth E. Robinson. I indicated to the Chief Education Officer, Mr. Sinclair Richards, that I would be available to serve in the Bermudian educational system in September 1978.

From January 1978 to September 1978, six positions were advertised—three for principal and three for education officer with special responsibilities in the area of curriculum. I never received any notification of those vacancies. I was, however, sent a list of teaching vacancies. Isn't that discrimination by exclusion?

On March 31, 1978, Mrs. Rosalyn E. Burchell left her position as the reading teacher at Harrington Sound Primary School. The next day—April 1, 1978—she went to the Ministry of Education as an assistant education officer responsible for curriculum. Mrs. Burchell was not required to complete any further coursework or practical training relating to curriculum. Four months later, I would be completing my degree to become Bermuda's first qualified curriculum coordinator, in accordance with international standards. I did not even get the opportunity to apply for the position of assistant education officer responsible for curriculum. Ironically enough, I was offered the position as reading teacher at Harrington Sound Primary School.

Mr. Mansfield Brock, the Permanent Secretary for Education, in his correspondence to me, dated December 29, 1978, stated, "However, I found myself in the position of discovering in late August 1978, that you were available for September 1978—an impossible situation to offer you anything commensurate with your training and qualifications, especially since our budget was fixed in October 1977."

Is that the truth? How does he regard the letter from Dr. Orval Conner that is in my file? Dr. Conner was one of my professors in curriculum at Miami University. The letter was addressed to Mr. Brock and copied to Mr. Sinclair Richards. That letter was sent on June 1977, after I had completed all of my course requirements.

Typed below is the correspondence from Dr. Orval Conner, Professor at Miami University to Mr. Mansfield Brock. It was stamped "received June 29, 1977" by someone in the Ministry of Education.

Mr. Mansfield Brock
Permanent Secretary for Education

Dear Mr. Brock,

It has been our pleasure to have Mrs. Muriel Smith with us in advanced graduate study for the past three years. She is now completing her studies and will be returning home soon. I know she looks forward to this and is anxious to resume an active role in her profession.

Mrs. Smith has performed very well with us, and I have every reason to believe that you will find her equipped to render help and leadership in any of several possible roles in education. She is a fine individual both as a person and as a professional.

Her skills are such that I would judge her to be prepared for effective leadership as an elementary principal, a supervisor, coordinator, or director of elementary education, or as a staff person working in early childhood education. She works well with people and ideas. We are pleased to have had the opportunity to know and work with her, and are confident she will continue to bring credit to Bermuda and Miami University.

Sincerely,

Orval M. Conner, Ph.D.
Professor, Educational Leadership

CC: Mr. Sinclair Richards

How come both the Chief Education Officer and the Permanent Secretary for Education could not capitalize on the opportunity to bring a qualified Bermudian as a cur-

riculum coordinator into the Ministry of Education? In further correspondence, Mr. Brock said, "Personally, I am convinced that you have a great deal to offer Bermuda, and I would like very much to make use of your skills and abilities to further develop our educational system."

How could a graduate student get permission from the Ministry of Education to carry out her research study on the country's educational system and the Permanent Secretary not be aware of it?

Was there any level of interest shown by the Ministry of Education in following the developmental process of a Bermudian who was aspiring for the highest qualifications in the field of education? Every piece of correspondence regarding permission to do the study and request for cooperation from Education Officials in administering my questionnaire was not only sent to the Chief Education Officer, but also to the Permanent Secretary.

It has been brought to my attention that both Mr. Sinclair Richards, the Chief Education Officer, and Mr. Mansfield Brock, the Permanent Secretary for Education, were involved in coursework at the doctoral level at Nova University in Florida. It is my understanding that neither of them has acquired that degree yet. They commanded two of the top positions in the education system with Master's degrees. Rather interesting!

In September 1978, when I returned to Bermuda and all the positions in curriculum development and educational administration were filled, I concluded that there must have been a calculated effort to make sure I did not obtain a position in the Ministry of Education, because I was not even afforded the courtesy of being notified about any of those vacancies so that I could at least apply for the jobs.

Of course, I protested. I talked to newspaper and television reporters. The Honorable Quinton Edness, who was the Minister Community Affairs, invited me to come and discuss my situation with him. In the course of our conversation, he said, "Mr. Jimmy Brock, the Permanent Secretary for Education, said, 'Who, her? She is going to upset the applecart.'"

At that time, my response was, "Upset the applecart? Not just upset it! Turn it over!" Now, twenty years later, I boldly declare, "Not only turn it over, but get a new applecart."

I made an appointment to see the Permanent Secretary for Education. He offered me a position as a reading teacher at St. George's Secondary School. He also indicated that should I oblige, when the time came, he would see to it that I got a promotion.

Thank You, but no, thank you! I refused to subject myself to such insults, injustices, and indignities. How could I subject myself to such belittling and discriminating behavior?

My family and I had endured tremendous sacrifices. We had spent three years abroad, without the benefit of pay, so that I could prepare myself to obtain the highest qualifications in the field of education. What had I done to deserve that kind of treatment? All I had done was adhered to the advice and followed the examples of my sterling, thoroughbred Bermudian and West Indian teachers, who not only had instilled in me the desire to learn, but had also continually impressed upon me the importance of aspiring to the highest heights in any endeavor that I undertook.

Consequently, I refused to take the job as a reading teacher. There is such a thing as being treated with dignity

and respect. Had I accepted, I would have been a disgrace to all persons who have ever acquired doctorates. Let me hasten to add that if the reading position was the only job that was available in my country when I returned home, I willingly would have taken the job and would have waited until a vacancy in the area of curriculum occurred.

As a Bermudian who had been awarded a teacher-training scholarship and secondment, I felt the Ministry of Education was remiss in its responsibilities—not only to me, but also to the people of Bermuda—to keep me informed of the vacancies that occurred in the educational system. Where was its commitment to encourage Bermudians to become better qualified in order to be placed in positions of leadership? Someone in the Department of Personnel and Services indicated to me that, on occasion, they have even paid for Bermudians to fly home to be interviewed for various job positions.

I had the decency and manners to keep the Ministry of Education informed of my progress. I do feel Dr. Kenneth Robinson, the former Chief Education Officer, showed vision, foresight, and professionalism in the case of Dr. Norma Astwood, a former school psychologist. She was seconded to Adelphi University. On the completion of her studies, the position of school psychologist was advertised. She applied and was successful in becoming Bermuda's first school psychologist.

As a result of my experience, some serious questions about the qualifications and requirements for positions in the Ministry of Education have arisen: (1) Should Bermudians who are studying abroad be notified by the government of Bermuda about vacancies that occur in the system; and (2) should Bermudians in leadership positions in

the Ministry of Education have a doctorate as the minimal requirement?

It is my firm belief that I was discriminated against by means of exclusion. How could a ministry need someone in curriculum development and completely ignore and exclude an individual who sacrificed to achieve the highest qualifications, practical training, exposure, and experience in that area?

Under the present system, an elementary or secondary school teacher can apply for a position in curriculum development and be successful in their application without the benefit of further coursework, practical training, and field experience. Appointments made under those arrangements do not allow for fresh innovations and stimulation in the system. There is no guarantee that the best-qualified person will get the position. Consequently, the whole system suffers as a result of that methodology, and encourages mediocrity and stagnation.

The question then becomes, What criteria is used to evaluate the suitability of the candidates for the positions? Does favoritism enter here? In America, where I majored in the area of curriculum, in order for someone to apply for a position in curriculum development, a minimum amount of coursework is required and one must have engaged in practical field experiences in the area of curriculum. This is not the case in Bermuda. Almost anyone can apply. Has the time come when more specific standards should be required for the top positions in the Ministry of Education? Where there is no vision, the people perish. Are Bermuda's children perishing because of the lack of vision of the educational authorities?

In 1991, I mustered enough courage to apply for two positions in ministries outside of education. One was the

coordinator for the Child Development Project. It looked like the ideal situation for me. Early childhood education had always been my heartbeat. I had experienced great success challenging those little people, whose minds were like sponges, so ready to absorb learning.

It was a project being jointly sponsored by the Ministry of Education and the Ministry of Health and Social Services. Before I was even interviewed for the position, I was told by a high-ranking official in the Social Service Department that I would not get the job, because it was tailor-made for Mrs. Conchita Ming, a social worker in the Ministry of Health and Social Services. I was too dumbfounded and too naïve to believe that.

Would they give the job to someone who had a Master's degree in social work? Would they prefer someone who had no educational training and teaching background? I had obtained the Primary Specialist Certificate—training specifically designed to meet the needs of nursery-school and preschool children. I had years of teaching experience with that age group and a doctorate in educational administration! Would I be overlooked for someone less qualified?

Believe me, they did it! The trend in some ministries is to take one aspect of a broader subject area and to promote a program based on that aspect. In this case, the aspect was parental intervention, a part of the total field of early childhood education. If they had tailor-made the job for a particular individual, why had they bothered to deceive other interested, sincere applicants; in my case, an applicant who was more qualified than the person that was chosen. Why do they subject people to such insults, injustices, and indignities?

In spite of being more competent, more capable, more committed, and more qualified with more practical

experience, exposure, and expertise, I was overlooked for a lesser-qualified person.

WHO ASSESSED MY SUITABILITY?

I swallowed the hurt, the wounds, and the pangs of rejection. The other job position was community education coordinator. The Minister of Community Affairs, the Honorable Quinton Edness, CBE, encouraged me to apply for the job. I even shared with Mr. Lowdru Robinson some ideas for a proposal that I had gleaned from a course in community education, which I had taken while pursuing the doctorate.

If there was ever a time I felt I would surely get a job, it was this time. Wrong! I was in Cincinnati, Ohio, when I called home to my family. Imagine my shock and dismay when I learned that Mr. Henry Douglas had been the successful applicant. He had a master's degree, and he has enjoyed upward mobility to the extent that he became the Director of Community Affairs, and has recently retired from this position.

I was deeply crushed and wounded. What was wrong with me? All I did was study and prepare myself to be the best qualified in my field. Why was I continually overlooked? I couldn't understand it.

It was after that unsuccessful application that I vowed I would never go before the Public Service Commission again. I had figured out their game. Regardless of how competent, capable, committed, or qualified you were, the Public Service Commission acts on the advice of the Permanent Secretaries of the various ministries. In order to be a successful applicant, what is required? Qualifications? Practical

Training? Years of experience? Or is it finding favor with the Permanent Secretaries of the various ministries?

Enough of the bureaucratic red tape! Since I could not be treated with dignity and respect nor be shown justice and equality, I decided to function on my own. It was twenty years later, while continuing to search for the reasons for my failure to secure a job in my country, that I was informed by Mr. Kenneth Dill, Executive Director of the Human Rights Commission, that someone had blackballed me by putting something in my file that has hindered me from getting employment in my country.

I was totally shocked and stunned. "Who?" I asked.

His response was that it had something to do with something I had done when I'd first come back with my Ph.D.

What a blow right in the pit of my stomach! It took me a few weeks to fathom the implications and ramifications of what Mr. Dill had revealed to me. Who could have done such a thing? What could they possibly have said? What had I done when I first returned home with my doctorate? As far as I was concerned, all I had done was demanded to be treated with dignity and respect, and I had refused to accept any insults, injustices, and indignities that were being meted out to me by people who were responsible for the education of the nation's children. After all, I was a Bermudian. Were their actions and attitudes indicative of a country that had the welfare and interest of its citizens at heart?

I finally reached the place where I decided to go to the Ministry of Education and check to see what was in my file. I spent approximately six hours, on two separate occasions, reviewing my file.

On the last day, when I returned home, I stood in front of the mirror, looked myself dead in the eye, and burst out

laughing. Laughter is good medicine, indeed. I pointed my finger at myself and said, "Muriel, be for real. Is that what you wrote those people twenty years ago? You had to be full crazy. You are absolutely plain foolish. What would make you think those people were going to give you a job in this country? You had as much chance of getting a job in this country as a snowball has of surviving in hell."

Interestingly enough, in my file, I came across correspondence from Mr. Lowdru Robinson, who then had been the Director of Community Affairs. It was addressed to Mr. Sinclair Richards. Mr. Robinson was requesting a confidential report on my work history and his comments on my suitability for the position of coordinator of the Community Education and Development Project.

Written in pencil at the bottom of the page was this: "Oral feedback given by CEO and Miss Thomas. JSR."

What was the nature of the feedback given by the Chief Education Officer and Miss Ruth Thomas? Did the oral feedback hinder me from securing the job of coordinator of the Community Education and Development Project? Were those persons adequately equipped to assess my ability for that post? Did Mr. Lowdru Robinson confer with my professors at Miami University to assess my suitability for the post? After twenty years, I am just finding out that Mr. Sinclair Richards and Miss Ruth Thomas gave an oral report about my suitability for the position of coordinator of the Community Education and Development Project?

I served under Miss Ruth Thomas, the Education Officer responsible for Early Childhood Education. That was for two years when I worked at the Lyceum Nursery as the teacher-in-charge from 1973 to 1975. Miss Thomas had a teacher-training certificate and a diploma in education from

London, England, and she also worked at the school for the handicapped. During the time that I served under Miss Thomas, I obtained my Master's in elementary education. Consequently, I was better qualified than the person that was responsible for my professional growth and development.

At the end of my two-year stint at Lyceum Nursery, I submitted some recommendations to improve early childhood education in Bermuda. Did I ruffle some feathers when I submitted those recommendations? It seemed like my sincerity and my commitment to improve the quality of education for Bermuda's children got me in trouble. Dr. David Saul, who was the Permanent Secretary of Education at the time, wrote me in Oxford, Ohio, and told me that the ministry does not act upon recommendations submitted by ex-teachers of the system.

I was on study leave pursuing the doctorate; I was not an ex-teacher. I answered him accordingly. By the way, how did Dr. David Saul, a White Bermudian, become the Permanent Secretary? He had been living in Canada, and Mrs. Gloria McPhee, a Black Minister of Education, had invited him to return to Bermuda and had commissioned him to do a survey of Bermuda's educational system. Then she had recommended that he be given the job of Permanent Secretary of Education. After that, he enjoyed the full extent of upward mobility by serving in top positions at Fidelity Management and Gibbons Company, as well as being Financial Secretary and Minister of Finance; eventually he inhabited the highest office in the land, that of Premier.

Why was my return to my country so harsh and discriminatory? After all, Dr. Saul and I were both Bermudians, and we both had the same qualifications—Ph.D. in educational administration. Does a White Bermudian male have the inherent right to top managerial positions while a

Black Bermudian female is subjected to insults, injustices, indignities, and unemployment?

On November 10, 1997, I applied for the job of Education Officer in Social Studies within the Ministry of Education. The job description stated,

> Under the direction of the Senior Education Officer, Curriculum, Instruction, and Evaluation, the successful applicant will manage the implementation of the social-studies program in the school system. The post holder will be responsible for preparing curriculum and providing for the professional development of school staff in the area of social studies.
>
> Other duties include:
>
> - Researching changes in social-studies programs internationally and making recommendations for modifications in the local programs appropriate.
> - Consulting with local organizations concerned with the political and social history and traditions of Bermuda, and making recommendations for modifications in the social-studies program or for training of staff as appropriate.
> - Evaluating the effectiveness of the instructional program in social studies.
> - The applicant must be a trained teacher with a master's degree or equivalent in social studies or a related area. A minimum of five years teaching and administrative is required.

There was an answer required in the "additional information" section. It stated, "Please state in your own words and in handwriting why you are an applicant for this post,

mentioning any specific achievements or personal quali-
ties which you think may support your candidature."
My response to that was as follows:

> In August 1978, when I obtained a Ph.D. in educa-
> tional administration, I had the distinction of becoming
> Bermuda's first qualified curriculum coordinator in ac-
> cordance with international standards.
> Unfortunately, however, over the past twenty years,
> I have not been afforded the opportunity to utilize my
> skills, competencies, capabilities, and expertise in the
> area of curriculum, to give something back to the sys-
> tem that produced me.
> Consequently, when I saw the advertisement for an
> education officer to be involved in the implementation,
> research, and evaluation of curriculum in the areas of
> social studies, I became quite enthused and excited.
> Something tingled in the innermost recesses of my
> being, and I felt duty-bound to apply for the position.
> Perhaps this may be my last opportunity to apply for a
> position in which I could make a very valuable and wor-
> thy contribution with respect to the further inclusion of
> the political and social history and traditions of Bermuda
> in the system's curriculum.
> I also believe I possess several areas of experience,
> exposure, and expertise that would support my candi-
> dature for the position of education officer with respon-
> sibility for the social studies curriculum in the system.
> These areas include my varied academic and edu-
> cational experiences, years of successful teaching and
> varied administrative leadership experiences, strong in-
> terpersonal skills exhibited in working with different
> age groups and personnel, broad organizational and
> communication skills, and my own willingness to grow
> academically and personally.

Once again, in spite of my competencies, skills, capabilities, commitment, experience, exposure, and expertise, I was overlooked for a younger male, Mr. Llewellyn Simmons who did not take up the post immmediately after being appointed in March 1998 because he is abroad completing doctoral studies. In the meantime, I understand that a former Education Officer with a Master's degree in History is being used as a "fill in." Not that I expected to be chosen, but the decision of the Public Service Commission substantiates my argument that regardless of how qualified a person is, if you are not the favorite of the Permanent Secretary, you will not be appointed to any position. What was most insulting, however, was being interviewed by the Senior Officer for Curriculum, Instruction, and Evaluation, who I remember as being a guidance counselor. She has a Master's degree in Guidance and Counseling, and she is responsible for the development of curriculum for the system. Is it any wonder that when the auditors came to evaluate the system, not only did they give the system a failing grade, but also the area with the most dismal and depressing results was curriculum? It is interesting to note that many unqualified persons are in high-salaried, top-level positions without the needed minimum skills and competencies to perform in an effective manner within the system. Additionally, over the past years, the Ministry of Education has hired a white non-Bermudian, Dr. Helen Stemler as a Curriculum Consultant.

Chapter 5

Justice and Equality

Racism is an evil weed sown in the garden of humanity. It has grown wildly, entangling the healthy plants and covering the pathways, creating a great maze, a labyrinth with twists and turns that have led humanity astray. Racism has entwined and entrapped us all.

—*Joseph Barndt*

WHITE IS RIGHT

What is justice? Justice is conduct that shows that one is acting in accordance with what is morally right or fair.

What is equality? Equality is having the same rights or status.

Why have I chosen to write about the discriminating experiences that I feel have been meted out against me by the administration of the Bermuda College? It is because after twenty years of dealing with incidences in isolation, all of the pieces of the puzzle have come together, and I now know that I have been fighting two horrible monsters: institution-

alized racism and colonialism. As a Black woman, the pistols were loaded against me.

In March 1982, I applied for the job of Director of Extension at the Bermuda College, Bermuda's only institution for higher education. In the job advertisement, the job's focus was on curriculum development, and it also stated that preference would be given to someone with at least ten years of administrative experience. That, in my opinion, was a very poor and inadequate requirement for a position in which the main thrust was curriculum development.

Mr. Peter Doyle, who was serving as the principal of Northlands Secondary School was the successful applicant. Mr. Doyle had a teacher-training certificate from England and a Bachelor's degree from Queen's University in Ontario, Canada. He also had acquired some administrative experience while serving as the principal of Northlands.

While attending Miami University, some of my job responsibilities had included the following:

- Diagnosing reading difficulties of elementary, secondary, and college students, as well as adults
- Teaching the SQ3R study-skills method to college students
- Preparing materials for summer reading workshops
- Program planning for a competency-based teacher education program for college students
- Assisting college students to meet degree requirements of Miami University
- Conducting workshops for parents
- Supervising student teachers

Basis coursework at the doctoral level had included:

- Elementary school curriculum
- Curriculum development in the public schools
- Seminars in curriculum and supervision
- Advanced seminar in curriculum theory
- Practicum in curriculum and supervision
- Seminar in elementary education
- Educational research
- Educational statistics

As a doctoral candidate, I had been engaged in various enrichment activities, such as serving on different committees and attending workshops, symposiums, and conferences.

Why—with my experience, exposure, and expertise—had I been overlooked for a lesser-qualified White male? Why—with my competencies, commitment, capabilities, and qualifications—had I been subjected to the indignity, injustice, and insult of being ignored for a lesser-qualified White male?

It was fourteen years later, in June 1996, that the job of Vice-President, Academic and Student Affairs was advertised. Why not apply? I have the deepest confidence in my ability to go to the Bermuda College—or anywhere for that matter—and motivate, stimulate, and challenge students to excel academically.

I was not even considered for that position. It was interesting to note that the person who was retiring from the position of Vice-President, Mrs. Solange Saltus, had a Master's degree in Counseling. She had started out as a counselor at the Bermuda College and had worked her way up to the number-two position at the college. With a Master's

degree in Counseling, she could occupy the position, but with a Ph.D. in Educational Administration, I could not even be considered for the position. Why such a disparity?

What is the college's policy about qualifications needed for job positions at this institution? Is having a doctorate an adequate qualification for a job position at the college? Is there a uniform standard with respect to qualifications at the college? It is rather interesting to note that for a job of such high caliber, the administration, in the advertisement of the job under Minimum Qualifications indicated the following, "The Vice-President, Academic and Student Affairs, will possess academic qualifications at least at the Master's degree level in an academic area and preferably at the doctoral level from an internationally recognized university. . . ." In my estimation, for the number-two position at the Bermuda College, to even encourage applicants with a Master's degree to apply for the position, was a very meager requirement. Such limited expectations breed mediocrity.

FOREIGN IS SUPERIOR

The successful applicant for the position was Dominican-born Dr. Donald Peters. In spite of the impressiveness of Dr. Peters' credentials, I have problems believing that his appointment demonstrates the sincerity of a board of governors committed to Bermudianization at the Bermuda College.

Following is the letter I wrote after the announcement of the appointment of Dr. Peters as the Vice-President for Academic and Student Affairs.

March 4, 1998

Dear Fellow Bermudians,

"Racism is an evil weed sown in the garden of humanity. It has grown wildly, entangling the healthy plants and covering the pathways, creating a great maze, a labyrinth with twists and turns that have led humanity astray. Racism has entwined and entrapped us all."

—*Joseph Barndt*

Racism is a global issue, and even though Bermuda may pride itself on being another world, this evil scourge is rampant in this island. No longer can we, the citizens of this country, put our heads in the sand like the ostrich and pretend that Bermuda is set apart from racism. Can the White minority continue to be permitted to maintain itself with incredible privilege at the expense of Blacks in this country?

How does this racism translate into our daily existence? Just recently, the Bermuda College announced the appointment of Dominican-born Dr. Donald Peters. I have to be honest and admit that I am quite impressed with his experience, exposure, and expertise. I am, however, concerned that the Board of Governors of the Bermuda College chose to ignore two Black, Bermudian women in making the appointment.

Even though I was not short-listed for the position, I remind you that in 1982, I applied for the position of Director of Extension and was overlooked for a lesser-qualified, White male. I hasten to add that, had the college had any vision and commitment to Bermudianization and had not discriminated against Black, Bermudian women, the position of Vice-President could well have been my lot.

I bear no ill will toward the people who have discriminated against me in my three attempts to obtain a position at the Bermuda College. I have now joined the ranks with Dr. Eva Hodgson, a very prominent and capable educator, who also applied to the Bermuda College on three occasions and was overlooked for lesser-qualified persons.

Why couldn't Dr. Hodgson and I have aspirations to be not only the Vice-President, Academic and Student Affairs, but also the President of the Bermuda College? I say to my fellow Bermudians, racism takes a heavy and costly toll if you are a Black, Bermudian woman.

After twenty years of fighting, it hit me like a ton of bricks. I was naïve. I could not fathom that I was being discriminated against in my own country. I only realized what had happened to me on December 10, 1996, when I read the article in the *Royal Gazette* entitled "Teacher Takes College to Rights Commission." As a result of this revelation, I am now at peace with myself. I have finally accepted the fact that I am that prophet without honor in my own country.

I do, however, plead the cause for Dr. Lorita Alford. She is a Black, Bermudian woman presently working at a university in Tennessee, who applied for the position and was granted the favor of being short-listed. I, along with Dr. Hodgson, can readily share her pain and disappointment at being rejected in her homeland for a Black, non-Bermudian. To further exacerbate this ache, positions such as Vice-President of Academic and Student Affairs do not occur that often. In my case, it was fourteen years after I first applied that the job was advertised. Will Dr. Alford ever get the opportunity to give something back to the country that produced her?

I am begging the women's organizations of this country to take up the cause of Dr. Alford. Can we continue

to sit idly by and let our women—and especially our Black women who have sacrificed and qualified themselves—suffer these indignities, these injustices, and these insults? The Board of Directors has indicated by its actions that they prefer a Black, non-Bermudian male to a Black, Bermudian female. They must be accountable to the Bermuda public for their actions.

Women, I say unto you, "Rise up! Make your voice heard! What will we tell our children and our grandchildren if we continue to let our 'daughters of the soil' be overlooked for non-Bermudians?"

Hasn't the time come when we must call for a thorough investigation of the policies and practices of the administration of the Bermuda College? What is the Bermuda College's commitment to Bermudianization of the institution? How about the Ministry of Labor, Home Affairs, and Public Safety? Shouldn't there be some serious investigation into the operations of that department? They are the people responsible for issuing work permits to non-Bermudians. Is there a place for highly qualified, Black, Bermudian women at this institution?

I rest my case. It has been my lot in this country to expose the unfair and unjust practices in this country. My family and I have had to pay a price for the role I have played. I am, however, at peace with myself. I have found my place outside of my country. Someone said to me, "Muriel, Bermuda is not ready for you yet. You are before your time."

My response was, "Bermuda is not ready for me because I am a free woman. I am an Afro-Caribbean woman. When I attended Central School and the Berkeley Institute, which were segregated schools, I was always taught that the color of your skin does not make you inferior.

Bermuda will only be ready for me when all right-thinking Bermudians realize that it is not Dr. Hodgson,

it is not Dr. Alford, and neither is it me. It is a system that works against Bermudians, women, and Blacks—three majorities in this country whose needs are not properly addressed.

Take my advice! A change has to come! To try to work in the system causes Bermudians, women, and Blacks to settle for the crumbs. Go for the whole pie! If you are committed to changing the plight of Bermudians, women, and Blacks, exercise the power of your vote at the next election.

Can a White male at the helm of this country be sensitized to the needs of Bermudians, women, and Blacks? He only has one of those characteristics: He is a Bermudian.

Can a Black male, as premier of this country, be fully committed to the needs of Bermudians, women, and Blacks? He, too, has only two characteristics: He is a Bermudian, and he is Black.

Can a White female take the bull by the horns and cause significant changes to be made in the status of Bermudians, women, and Blacks? Alas, she, too, has only two characteristics.

Remember, I said that you were to go for the whole pie. Why not align yourself with someone who has all three characteristics: someone who is a Bermudian, a woman, and Black—a woman, born out of struggle, who can effectively dismantle racism and bring about a just and free multicultural and multiracial society in a united Bermuda?

Thank you for your attention. I leave Bermuda knowing my mission is complete and my continued prayers will be with this island. For, above all, it is going to take a God of freedom, a God of justice, and a God of equality to tear down the walls of racism and to achieve the goal of freedom for all people.

I close with these words of liberation that God spoke to Moses:

> I have also heard the groaning of the children of Israel, whom the Egyptians keep in bondage; and I have remembered my covenant. Wherefore say unto the children of Israel, "I am the Lord, and I will bring you out from under the burdens of the Egyptians, and I will rid you out of their bondage, and I will redeem you with a stretched out arm, and with great judgements: And I will take you to me for a people, and I will be to you a God: and ye shall know that I am the Lord your God, which bringeth you out from under the burdens of the Egyptians." (Exod. 6:5–7)

Yours for a United Bermuda,

Dr. Muriel M. Wade-Smith

In October 1996, I applied to the Bermuda College once again. It was for the position of Curriculum Consultant. To be truthful, when I saw the advertisement in the *Royal Gazette,* an old spark tingled within me. Finally, maybe this was my opportunity to work in the area of expertise for which I qualified. Should I apply? I vacillated between affirmative and negative responses. Will they reject me once again for lesser-qualified Black, White, or foreign males and females? The apprehension was still there. With a very concerned and sincere heart, I prayed, "Lord, if it is not for me to apply for this job, then, tonight, while I am sleeping, erase all thoughts of this job from my mind."

The next morning, it was as if some compelling force drove me to the computer. I hastily completed the application and mailed it that very day. Alas, was trouble brewing? On the deadline date, October 29, 1996, someone from

the college visited my house. When I returned home, I received a message that Mr. K. Smith, associate dean in the Department of Applied Sciences wanted me to contact him at the college.

The following day, I called Mr. K. Smith, and he regrettably informed me that he had lost my application. He asked if I would be able to have another application ready as soon as possible. He told me he could come and collect it in the next hour. Fortunately, for me, I had stored everything in my computer and was able to hand Mr. Smith the application when he arrived at my door.

I asked him whether there were several applicants for the job. He replied that there were only two. On Friday, October 31, I went to the college for the interview. There were four people on the interviewing committee. During the interview, Mr. K. Smith asked me if I was familiar with DACUM. I replied in the negative. He told me that DACUM means "developing a curriculum." One of the committee members asked if I would be able to work full time should the position, which was presently part time, become full time. I indicated that such a change would not affect me. I was told that the committee would make their decision and I would be notified by November 6, 1996.

After leaving the interview, I met someone who asked, "What are you doing up here?"

"I've just been interviewed for the job of Curriculum Consultant," I replied.

"Good, I'm glad a Bermudian is applying. The girls in the office said they are creating this job for the Dean's wife, and it is a job a Bermudian can do," continued the individual.

I responded, "Well, it seems like I have thrown a monkey wrench in the works. Mr. K. Smith told me that there were only two applicants. Perhaps it is tailor made for the Dean's wife."

The person swerved to the right and continued, "See that woman over there? She's the Dean's wife. She is the other person who is applying for the job."

My reply was, "Oh! She must be going for her interview now. What qualifications does she have?"

The individual shrugged their shoulders but tried to assure me that Mr. K. Smith was committed to Bermudianization.

On November 6, 1996, I received a telephone call from Mr. K. Smith. He informed me that my application was not successful. He proceeded to tell me that the main reason my application was rejected was because I was not familiar with DACUM and that I had not been involved in curriculum development since I graduated.

The successful applicant was the wife of the dean, and she did not have a Ph.D. in educational administration with a major emphasis in curriculum development. It is my understanding that she is also a Canadian citizen. They chose a lesser-qualified foreigner rather than give a born-and-bred Bermudian the opportunity to make a contribution in her country.

I had also applied for the position of tutor at the college. I received a letter from Mrs. Sheridan Talbot, informing me that applicants for the post were being short-listed and that she would contact me should I be required for an interview. Mrs. Talbot was a member of the interviewing committee for the Curriculum Consultant position. I refused to allow myself to be subjected to any further insults,

injustices, and indignities. Therefore, I withdrew my application for the position of tutor.

I made three unsuccessful attempts to obtain a position at the Bermuda College. What was wrong with me? The Executive Director of the Human Rights Commission advanced the argument that there was something in my file that caused me to be overlooked. He further indicated that I had been blackballed.

How about Dr. Eva Hodgson's file? Was there something in her file too? A Black, qualified woman who had applied to the Bermuda College on three occasions and had been displaced by lesser-qualified expatriates. We are not the only two qualified, competent Bermudians who have been victims of institutionalized racism.

From my experience with the Bermuda College, a very clear message of discrimination has been relayed to me. The message is that White males—such as Dr. Archibald Hallett, the first President of the Bermuda College, and Dr. George Cook, the current President of the Bermuda College—have an inherent right with their Ph.D.s to become president of the country's only higher-learning institution, while other equally qualified, Black, Bermudian women aren't even allowed to get their foot in the door.

In 1952, Dr. Kenneth E. Robinson—a very prominent educator, a graduate of Harvard University, and the first Black Chief Education officer in the Ministry of Education in Bermuda—in his dissertation entitled "History of Education in Bermuda," found it necessary to list a major educational philosophy, goals, and objectives with which colored Bermudians should be concerned. One such objective he indicated was "to cultivate White children for hereditary leadership." Have Dr. Hallett and Dr. Cook and

others at the Bermuda College tried vigorously to uphold that discriminatory objective?

The message of discrimination from the administrators at the Bermuda College, although quite subtle, is very clear. As a Black, female, qualified Bermudian, I have not been afforded the privilege of being treated with dignity and respect. Nor have I been shown justice and equality in my right to aspire to become the President of the Bermuda College. I have not even been able to get my foot in the door with lesser positions, such as Director of Extension, Vice President, Academic and Student Affairs, and Curriculum Consultant.

I pose the argument that had I been treated justly and fairly and been rightfully appointed as the Director of Extension, this would have been the first step and the right direction in my aspirations to becoming President of Bermuda College.

I quote from the article entitled "Essentials" by Ruth Simmons, College President. This article can be found in the August 1996 edition of *Essence Magazine.*

> Ruth Jean Stubblefield Simmons made history when she was installed as the ninth president of Smith College last September, becoming the first Black woman named to head one of the elite "Seven Sisters" Ivy League women's colleges. Despite growing up in rural poverty in Grapeland, Texas, as the youngest of twelve siblings, Simmons excelled academically and went to Dillard University in New Orleans, where she graduated summa cum laude. She received her master's and doctorate degrees in romance languages from Harvard in 1973 and had a distinguished career in a number of academic posts,

including provost at Spelman College and vice president at Princeton University, before coming to Smith last year.

The article continues with a section entitled "What It Takes" and quotes Smith as saying, "The typical academic track leading to a college-president position begins with completing the Ph.D. and teaching in the college level. Dean, vice president for academic affairs, and provost traditional lead to a college presidency."

The article ends with a paragraph entitled "Other Sisters at the Top." It states, "Other Black women heading colleges or universities include Johnetta B. Cole at Spelman College; Niara Sudarkasa at Lincoln University in Pennsylvania; Yolanda Moses, The City College of New York; Blenda J. Wilson, California State University, Northridge; Carol D. Surles, Texas Woman's University; Gloria Randle Scott, Bennett College; and Dolores E. Cross, Chicago State University.

What a price I have paid for discrimination! Not only have I been denied the opportunity of sharing with the students of my country the enthusiasm, the joy of learning, and the standard of excellence that was instilled in me as a student of the Bermudian educational system, but also the country has failed to reap the numerous benefits of my qualifications, competencies, capabilities, experience, exposure, and expertise. Additionally, my family has suffered unnecessary and untold financial hardships and emotional stress and strain because of such discrimination.

From 1982 until 1996, I would have had the chance to proceed through the ranks and acquire the experience that would have placed me right on target to assume the position of Vice-President of Academic and Student Affairs.

When Dr. Archibald Hallett and Dr. George Cook interviewed me in 1982 for the position of Director of Extension, I venture to say that those men were remiss in their responsibility and commitment to Bermudianization of the Bermuda College. I should have been snatched up as a candidate that could have been groomed to fulfill the goals of Bermudianization at the college. Instead of acknowledging that I had the same qualifications that they had, and affording me the opportunity to aspire to the same heights that they had attained, they chose to discriminate against me.

In essence, what Dr. Hallett and Dr. Cook indicated to me by their decision to hire Mr. Peter Doyle, was that they preferred a White male with less-qualified British and Canadian training, to a Black female, who was a born-and-bred Bermudian with Canadian training and the highest American qualifications. I am not the only one in this position. It is very painful to see one of my dedicated teachers from Berkeley Institute, Dr. Eva Hodgson, also in this predicament. One wonders if Dr. Hodgson and I are snubbed because of the false perceptions that American degrees are substandard in comparison to the supposedly superior and higher-caliber degrees from British and Canadian institutions. Can this be so? Dr. Hodgson not only has an academic degree from Colombia University, but from London University and Queen's College in Ontario, Canada as well.

When the full brunt of institutionalized racism and colonialism struck me a reeling, below-the-belt blow, I knew I could not be silent. Someone must fight for the cause of justice and equality for Bermudians, women, and Blacks.

I concluded, "There is no justice and no equality for a Black, qualified, female Bermudian in her native land of racist Bermuda."

Hopefully, my sacrifices, struggles, and battles will alter that conclusion; and after many more Bermudians realize what the struggle is all about, they will join forces to fight these deadly evils that are corrupting our country. Bermudians, women, and Blacks must adopt a justice-and-equality-at-all-costs stance and boldly demand and declare, "Let justice flow like the mighty rivers!" No longer must we tolerate foreigners displacing qualified Bermudians. No longer must we allow this male-dominated society to relegate women to a lesser, inferior status! No longer must Blacks be lulled into a stupor that makes them complacent about the indignity, injustice, and insult of being second-class citizens in their own country.

I owe this fight, not only to my children and my grandchildren, but also to all the children of Bermuda. Someone has to speak for those who cannot speak for themselves and for those who are fearful of being victimized. Hope lies in a God of equality!

Chapter 6
Country without a Citizen

A prophet is not without honor save in his own country.
(Matt. 13:57)

A BRITISH SUBJECT NO MORE

N ow when I leave here, this is it. I am finished. This is
the last time I will think of myself as a Bermudian. I
am a free woman. I am an Afro-Caribbean woman. I have
the deepest and sorest regrets that I was born a British sub-
ject. I don't want to be a British subject anymore!

What had brought me—a born and bred Bermudian who
was almost sixty years old—to such a point of disgust, dis-
illusionment, disappointment, and utter dismay, that I was
prepared to renounce and abandon all ties associated with
citizenship in my native land, Bermuda?

For twenty years, I had labored under the false impres-
sion that as long as I was qualified, competent, committed,
capable, and had the necessary experience, exposure and
expertise, I would be able to make a very worthy and

valuable contribution to my island home, the society that had produced me.

Wrong! I had been naïve, and I received a very rude awakening. In spite of being my country's first qualified Curriculum Coordinator, I was unable, in my country, to secure a position commensurate with my qualifications and to realize the resultant remuneration.

After filing two complaints, to no avail, with the Human Rights Commission, I was informed by Mr. Kenneth Dill, Executive Director of the Human Rights Commission, that someone in the country had blackballed me by putting something in my file, which hindered me from getting employment in my country. I reviewed my file, and the burden I carried for twenty years was lifted. As a result, it was no longer my problem. It was the problem of the government and the people of Bermuda.

Consequently, on August 6, 1997, when I visited the Premier, the Honorable Pamela Gordon, JP, MP, in response to her commitment to honor the tradition of openness and her desire to have Bermudians voice their frustrations, concerns, and hopes, my simple, candid, and only response to her question "What can I do for you?" was, "Nothing!"

What would make the Premier, me, or anybody else feel that something could be done for me when nothing had happened for me over the past twenty years?

Isn't it the same government, with the same policies, the same practices, and the same procedures that perpetuate institutionalized racism?

During the course of our conversation I told the Premier that my reasons for saying I expected her to do nothing were twofold. Firstly, I had joined the ranks with my forefathers, my brothers, and my sisters, who had to pay a

tremendous price and endure untold sacrifices in the continuing battle for justice and equality for Black people in this country. Secondly, as a Christian woman, I had no other choice but to appeal to a God of freedom, a God of justice, and a God of equality to intervene in Bermuda's situation and to rectify the injustices, insults, and indignities meted out to my people over the entire history of Bermuda.

When I left the Cabinet Office, I left the problem in its rightful place—at the seat of government. The pen is mightier than the sword. Therefore, I resorted to writing and placed the problem and the solution in the hands of the people of Bermuda.

Fellow Bermudians, you decide whether, in my native land, I have been blackballed in my attempts to secure employment befitting my qualifications, commitment, competencies, capabilities, experience, exposure, and expertise!

Miami University, my alma mater, you conferred the degree "with all the rights, privileges, and honors appertaining thereto." Have I been blackballed or have I been treated with the dignity and respect that you expect the graduates of your reputable institution to be shown?

How about you, America, the land of the free and home of the brave? Miami University is one of your institutions. Do you expect graduates from highly accredited and respectable institutions in your country to be subjected to such insults, injustices, and indignities?

Some may argue that what happened to me occurred twenty years ago. They boldly declare that those kinds of things are not happening now. They even question whether I am crazy for talking about discrimination. They proudly point out the numerous Blacks who are occupying many of

the top positions in the country and gladly remind me that we even have our first Black woman Premier.

I include here the article about Mrs. Valerie Wallace, a White Bermudian, who has also suffered insults, injustices, and indignities and has been displaced by a lesser-qualified foreigner. Was it at the hands of a powerful permanent secretary?

The article appeared in the *Bermuda Sun* on June 27, 1997. Miss Meredith Ebbin wrote it. It is entitled "Discrimination Complaint Lodged against Works Secretary:

> A land surveyor who has spent virtually all her life in government has lodged a complaint with the Human Rights Commission against her former boss, Works and Engineering Permanent Secretary Stanley Oliver.
>
> Valerie Wallace is alleging discrimination; she says Mr. Oliver has effectively blocked her bid to become the first Bermudian and the first woman to hold the post of government chief surveyor.
>
> She has been backed in her claim by former chief surveyor Nicholas Lonsdale, who described Mr. Oliver, in a letter to the Bermuda Association of Surveyors, as a "problem which obviously won't go away easily."
>
> Mr. Lonsdale, who worked as chief surveyor for twenty-seven months before resigning before the end of his contract in 1994, told the association that strong action should be taken by the Public Service Commission to remove Mr. Oliver from his post.
>
> "The problem that Valerie has . . . has nothing to do with her ability to perform the duties of this position," he wrote to the association. "It is purely and simply a personality conflict between herself and the Permanent Secretary.

"He made it very clear to me during my tenure that he did not like Val and would not, under any circumstances, entertain her as his chief surveyor.

"You have to understand, if you don't already, that the Permanent Secretary has a serious personality problem, the likes of which I have never run into before."

Mrs. Wallace, who was trained in the United Kingdom to be a land surveyor through the government bursary scheme, was in May, turned down for the post of chief surveyor.

Mrs. Wallace, whose application for the same post was turned down in 1994 as well, said government is now planning to offer the post to a non-Bermudian.

She is calling for an investigation into how Mr. Oliver runs the Works and Engineering Ministry and said as much in a meeting on Monday with Cabinet Secretary Leo Mills.

She said the last three chief surveyors, all of them non-Bermudian, including the current one, Robert Bedser, have quit their posts before completing their three-year contracts.

She said that and the high turnover of staff at the Ministry are indicators that all is not well at Works and Engineering.

She describes Mr. Oliver as a person with an autocratic style who does not delegate tasks.

She said, "He seems to prefer non-Bermudians. The only reason that I can give is they are going to do whatever he tells them to do."

Mrs. Wallace has now been transferred out of government to the Bermuda Land Development Company at the former US base, where she is commercial property manager.

She was seconded there in 1993 and accepted a permanent position there in May after she learned she was unsuccessful for the chief surveyor's post.

In a letter presented to Mr. Mills on Monday, she said she was encouraged in January by government's Director of Personnel Judith Hall-Bean to "abandon my career as a civil servant, and leave government because a powerful Permanent Secretary did not like me, or want me in the ministry."

Her bid for the top post has been backed by the Bermuda Association of Surveyors, which wrote a letter to the Public Service Commission on her behalf when they learned of her unsuccessful bid.

The Association also wrote to the Royal Institution of Chartered Surveyors, and they recommended that her resumé be compared against the job description of the advertised post. That was done by surveyor Arthur Jones, who concluded that she had the qualifications.

This week Mr. Jones's partner, surveyor Ian Waddington, called her failure to get the post "ludicrous."

Mr. Waddington, a partner at Jones Waddington, said Mrs. Wallace held the respect of surveyors in the private sector and [that she] knows more about property in Bermuda than anyone coming in from outside.

Somehow, I could not help but believe that what happened to Mrs. Wallace was similar to what had happened to me in 1977. What are the similarities?

We both are qualified, competent, capable, and committed women. Mrs. Wallace has had her dreams and aspirations to become Bermuda's first female chief surveyor crushed; I have had my dreams and aspirations of becoming Bermuda's first qualified Director of Curriculum, Instruction, and Evalu-

ation crushed also. The one striking difference is that she is a White Bermudian and I am a Black Bermudian.

I had the opportunity to be impressed with Mrs. Wallace's competencies and capabilities when I was checking out facilities for a school at the Base Lands. I sensed her enthusiasm, and she came across as a woman who was deeply entrenched in a viable, working vision for the Base Lands. I could not help but feel her love and dedication for her native land.

Sad to say, Bermuda has lost one of its "daughters of the soil," because Mrs. Wallace has returned to England.

As a result of my experience, I asked the following questions: Are the members of the Public Service Commission accountable to the citizens of this country for the decisions they make? How about the Presidents of the Bermuda College and the Board of Directors of this institution—do they have to answer to the citizens of this country for the decisions they make? Permanent Secretaries? Chief Education Officers? Education Officers? For that matter, anybody in positions of leadership, who is paid out of the public purse and is responsible for making decisions relating to Bermudians securing jobs.

Dr. Eva Hodgson—a brilliant, clever, and astute educator, who has fought untiringly to educate and enlighten Bermudians about the evils of institutionalized racism, which have been perpetuated by the government of the day, the United Bermuda Party—has come to the aid of Mrs. Wallace, myself, and the many, many other Bermudians who have been displaced by foreigners and who have been made to feel like second-class citizens in our own country. Dr. Hodgson is a Black Bermudian woman who also has been

displaced by lesser-qualified expatriates. She has presented a very clear solution to this vexing problem in an article entitled "Taking Responsibility for Our Failures," which appeared in the July 27,1997 edition of the *Bermuda Sun*. I have included the article here in its entirety.

> The nature of Soviet society, including the educational system, was the direct result of the policies of the Communist government. The nature of the South African Apartheid society, including its failure to educate Blacks, was a direct result of the Apartheid government.
>
> We all understand that. Why is it so difficult to understand that the nature of the Bermudian society, including the increasing violence and the failure to educate a large percentage of the Black male population, is the direct result of the policies of the UBP government.
>
> We did not need the Education Audit to discover that fact. Some of us remember not only the closing of the Howard Academy and the Technical Institute, both of which were making a significant contribution to the education of Black Bermudians, but we remember back to the time when Black Bermudians were told to their faces that to educate too many Blacks would mean that there would be a shortage of servants for White households.
>
> We remember, too, when the Berkeley Institute had to struggle to avoid becoming a trade school. We saw the development of the secondary schools in an environment of divisiveness, rejection, and lack of respect, and even contempt.
>
> When fellow Black Bermudians tell us that they support the UBP because they are "conservative," some of us know all too well just what has been "conserved," both in terms of educational policies and race relations or social policies.

The recognition that governments make policies which determine the nature of their societies and their educational systems is particularly important in society where far too many Black Bermudians still make political decisions on the basis of personalities rather than policies.

To pretend that a single civil servant, no matter how powerful or autocratic, is responsible for decades of failure to educate Black Bermudians to play the role in our economy for which we import people from every culture under the sun is a ridiculous red herring. A government policy of educational neglect and miseducation must be attributed to government policies, not one person.

The recent recall of the Agriculture Bulletin is evidence that autocratic and undemocratic attitudes are pervasive throughout our government. Few examples may surface because, despite the rhetoric, no one is recruited to the civil service who is not seen as complainant. Often the failure to perform is because the civil servant is consuming their energies to ensure that they are pleasing their political bosses rather than their client, the public.

Many Black Bermudians believed that our social, political and racial problems would be appropriately addressed because of the "people skills" of the former Premier, Sir John Swan. Now they are placing their hope on "a fresh young face" (or faces) with similar people skills. They would love to believe that our educational failures would disappear simply by removing a permanent secretary who lacks people skills.

Well, all of us need to recognize that the "people skills" of the former Premier have created an increasing uneducated Black underclass completely unprepared to participate in our sophisticated, prosperous economy because of government policies.

Our educational policies, like all else in our society, are a direct result of our government's racial attitudes and policies.

A friend said to me, "There are some good White people."

It will surprise no one if my definition of a "good White person" or, for that matter, a "good Black person," is someone who is concerned about the long-term, continuing impact of our racial history.

To them I say, "Race relations and educational policies will never experience any genuine shift unless we are democratic enough to believe that we can change our government."

As long as both the political and economic power is "conserved" as it has been, and Blacks continue to be so dependent on Whites economically, it is absurd to believe that merely changing faces or personalities will make any difference whatsoever."

My sincere desire is that Bermudans, women, and Blacks will unshackle themselves, unite their forces, and do the thing that is long, long, long overdue in this country: *change the government!*

Why should Bermudians, women, and Blacks continue to tolerate being displaced by foreigners? Why should Bermudians, women, and Blacks suffer the indignity of being second-class citizens or citizens without any birthright in their own country? Why should Bermudians, women, and Blacks allow this male-dominated society to relegate women to a lesser, inferior status?

As a Christian woman, I had no other recourse than to appeal to a God of justice and a God of equality. I share

with you a letter I wrote to the editor on April 12, 1998. It appeared in the *Royal Gazette* on Thursday, April 30, 1998, two days before my son Ashanti was killed on May 2, 1998. I share it with you.

April 12, 1998

The Editor
Royal Gazette
2 Par-La-Ville Road
Hamilton, HM 08

Dear Sir,

When I was a teenager, my family and I listened to a broadcast that was provided by the Leopards Club. It came over the radio every Thursday night at 6:30 P.M.

Somehow, as I reflect, I sensed a strong, deep spirit of togetherness, solidarity, unity, and oneness in purpose. The broadcast always started with the singing of the Negro National Anthem, "Lift Every Voice and Sing." I also remember feeling that there was a tremendous dedication and commitment to the cause of the Black man's struggle for freedom, justice, and equality. The atmosphere seemed to be charged with a freedom-justice-and-equality-at-all-costs attitude and posture.

There were fiery, eloquent speakers from America and the Caribbean who challenged Bermudians to have the courage to stand up for their convictions. When the speakers forcefully and boldly spoke out against the injustices, insults, and indignities meted out to Blacks, the broadcast was abruptly terminated.

This broadcast, however, had a very penetrating influence upon my life. I waited anxiously for the familiar strains of "Lift Every Voice and Sing" and wondered what

was on the speaker's agenda for each Thursday. That song touched every fiber of my being and caused me to know that as a Black woman, I was forever engaged in a battle for freedom, justice, and equality.

Those brave, courageous, and fearless "Leopards" made me realize that the only hope for my people was for us to trust in a God of freedom, a God of justice, and a God of equality. Over the years, I must admit I lost sight of the struggle.

Was I too involved in my educational pursuits, shopping trips, cruises, new houses, cars, boats, and furniture? Was I politically naïve? Something hindered me from vigorously pursuing the cause of freedom, justice, and equality for Bermudians, women, and Blacks.

After twenty years of failing to secure employment in my native land, I have recaptured that spirit, attitude, and posture passed on to me by my fellow countrymen, the Leopards. Thank God, I have found the monsters: institutionalized racism and colonialism.

Consequently, I have appealed to a God of freedom, a God of justice, and a God of equality to intervene and utterly destroy the evil strongholds of this island that have held its inhabitants enslaved, oppressed, and in bondage.

I have used a part of a verse from "Lift Every Voice and Sing" as the sincere and earnest prayer of my heart: "God of our weary years / God of our silent tears / Thou who hast brought us safe / thus far on our way."

God of freedom, God of justice, and God of equality, I am tired of this "institutionalized racism and colonialism" that has belittled me to that inferior status of a second-class citizen in the country where I was born and bred. I've had enough of being displaced by foreigners, for, while they work, I still owe the bank and my lawyers. How am I suppose to survive in a country that has

a system that works against me as a Bermudian, a woman, and a Black person?

God of freedom, God of justice, and God of equality, You created all men in Your image and in Your likeness! You are not a prejudiced God! You are not a slave-master God! You are not an Uncle Tom God! You are color-blind! You are a God of love, a God of truth, and a God of mercy!

God of freedom, God of justice, and God of equality, isn't it time for a change? Isn't it time for Bermudians, women, and Blacks to take the blinders off their eyes and realize that the running of this land, which You have given us is too important to allow it to sink to the lowest level of a personality contest between two Black women? Help us to know that it is about whom You have chosen as the woman who is best suited to bring about love, peace, and harmony among all Bermudians, regardless of race, creed, or color.

God of freedom, God of justice, and God of equality, we have had thirty years of the United Bermuda Party, and it is my humble opinion that as Bermudians we are less united, terribly displaced, and severely struggling to survive in our native land.

God of freedom, God of justice, and God of equality, isn't it time for Ms. Jennifer Smith, the leader of the Opposition, to take her rightful place at the helm of this country and lead us into the twenty-first century as a truly united Bermuda? Haven't you allowed Ms. Smith to be prepared to run our country? With much determination, we have seen her overcome failure and defeat. She has conquered insurmountable odds, come up through the ranks, and stands positioned to take on the challenge of letting Bermuda be a homeland for Bermudians.

God of freedom, God of justice, and God of equality, isn't it time for the Progressive Labor Party to take its rightful place as the government of the day and charter this country through the treacherous shoals caused by institutionalized racism and colonialism. Let them through the process of reconciliation apply healing salve to the wounds of Blacks, Portuguese, and Whites, as together we chart Bermuda safely back into harbor because of the party's commitment to all Bermudians and the issues directly affecting all Bermudians.

God of freedom, God of justice, and God of equality, prove Yourself to the citizens of this country and me by letting there be a "Change of Government." Speak to the hearts of Bermudians, women, and Blacks, and let them know racism is an evil scourge that has enslaved and entrapped us all. Free Your people from oppression, enslavement, and bondage by "Changing the Government."

I close with these encouraging words of liberation that God said to Moses:

> And I have also heard the groaning of the children of Israel, I am the Lord, I will bring you out from under the burdens of the Egyptians, and I will rid you out of their bondage, and I will redeem you with a stretched out arm, and with great judgments: And I will take you to me for a people, and I will be to you a God: and ye shall know that I am the Lord your God, which bringeth you out from under the burdens of the Egyptians. (Exod. 6:5–7)

For a truly united Bermuda,

Dr. Muriel M. Wade-Smith

After appealing to a God of freedom, a God of justice, and a God of equality, I rested my case. I left it right in the

Cabinet Office where it belongs, at the seat of government. Now, I have shared it with you, my fellow Bermudians. The problem and the solution rest with you. Do what you have to do at the next election: *Change the government.*

That's why on August 6, 1997, toward the end of my conversation with the Premier, I said, "Now, when I leave here, I am finished. This is the last time I will think of myself as a Bermudian. I am a free woman. I am an Afro-Caribbean woman. I have the deepest and sorest regrets that I was born a British subject. I don't want to be a British subject anymore!"

Full British Citizenship

The first practical step toward overcoming institutional racism is the recognition that people of color hold the key to change. Leadership and direction can only come from them. People of color understand racism far better than we do, and they know what needs to be done to eliminate it.

—*Joseph Barndt*

In February 1998, the Premier, the Honorable Pamela Gordon, along with leaders from the four other Dependent Territories, went to London to hold discussions with the British government. During those discussions, the question of full British citizenship for the citizens of the Dependent Territories surfaced. In 1982, the citizens of the Dependent Territories lost their British citizenship, and instead of holding a British passport, they were holders of a passport that indicated they were British Dependent Territories citizens.

I have included letters to various officials of the British government to discuss the fact that the promise of full British citizenship was not the most pressing issue facing the Bermudian people. The real issue was institutionalized racism in a British colony.

Letter to the Foreign Secretary:

January 27, 1998

Rt. Hon. Robin Cook
Secretary of State for Foreign and
 Commonwealth Affairs
Foreign and Commonwealth Affairs Office
Whitehall, London SWIA 2AH

Dear Sir,

"True peace is not merely the absence of tension, but it is the presence of justice" (—Rev. Dr. Martin Luther King, Jr.).

As a result of articles carried in the *Royal Gazette* recently, I have felt a strong compulsion that has driven me to share with you a draft copy of my book entitled *Country without a Citizen*.

I firmly believe my situation represents the condition of many, many Bermudians, who are finding themselves, as a result of blatant insults, injustices, and indignities, not only displaced by foreigners in their own country, but also suffering the additional affronts of being made to feel like second-class citizens and "citizens without a country" in their native land.

After you have read my book, I would welcome the opportunity to come to London and entertain discus-

sion about the real problem—institutionalized racism—which is plaguing not only Bermuda but also the whole world.

Thanks very kindly for your attention, and I eagerly await your response.

Yours sincerely,

Dr. Muriel M. Wade-Smith

CC: Rt. Hon Jack Straw, MP
Secretary of State for the Home Department

Letter to the Foreign Office Junior Minister:

February 5, 1998

Baroness Symons
Foreign Office Junior Minister
(Responsible for Bermuda)
Foreign and Commonwealth Affairs Office
Whitehall, London SWIA 2AH

Dear Baroness,

"In every institution, there are three distinct levels at which racism may be operating: attitudes and actions of personnel; policies and practices; structures and foundations. The last is the deepest of the three, for it embodies an institution's purpose and the philosophical basis for its operation" (—Joseph Barndt).

I have followed with much interest the comments in the daily reporting of our local newspaper, the *Royal*

Gazette. Over the past week, we have been inundated with reports by the media of the meetings held in London for the leaders of the Dependent Territories Association.

I noted with interest the following comment made by the Premier, the Honorable Pamela Gordon, in the February 3 edition of the *Royal Gazette.* I quote:

"'I expect that they really will propose some serious stuff,' Ms. Gordon said last night. 'It is a carrot-and-stick approach.'"

But she said in her talks last week with Foreign Office Junior Minister Baroness Symons, she made it clear that Bermuda would not pay any price for British citizenship.

She said Britain was especially concerned about its image as it had just taken up the presidency of the European Commission and was worried it would be held accountable for the actions of its Dependent Territories if they were in breach of its European treaty obligations.

While Britain, the Mother Country, may be worried about its image, many of Britain's citizens, Bermudians, are struggling to survive in their native land because foreigners are continually displacing them. Also, Black Bermudians have the additional disadvantage of being demeaned to that lesser, inferior status of second-class citizens in the land of their birth. Then, to add insult to injury, all Bermudians have no national identity and are treated as "citizens without a country." Perhaps you should read Dr. Eva Hodgson's book entitled *Second-Class Citizens: First-Class Men.*

Baroness Symons, it is my humble opinion that the real issue is not the promise of full citizenship, but institutionalized racism in a British colony. Over the past

twenty years, in my quest to secure employment in my homeland, I have been through the three levels of institutionalized racism that have brought me to that conclusion. I have analyzed the attitudes and actions of personnel. I have scrutinized the policies and practices of the United Bermuda Party, which has been in power in Bermuda for the last thirty years. Alas, the last level of racism is the deepest and the most serious. The structure and foundation of Bermuda is rooted in colonialism.

Consequently, if Bermudians want to remain enslaved, oppressed, and in bondage, then they have no other choice but to remain tied to Great Britain. If Bermudians, however, want to be free, have a sense of national dignity and national pride, and be in control of their own destiny, then they have no other choice but to opt for independence.

I have sent you a draft copy of my book entitled *Country without a Citizen*. It chronicles my struggles and battles to seek employment in my native land. This is how I have been treated as a British citizen in a Dependent Territory. Therefore, I state very emphatically, "I have the deepest and sorest regrets that I was born a British subject. I don't want to be a British subject anymore."

I bear no one any hard feelings. Hopefully, my life's struggles will awaken my fellow Bermudians to the need for their country to go independent.

Thanks very kindly for your attention.

Sincerely,

Dr. Muriel M. Wade-Smith

Enclosures

The Baroness's response:

Foreign & Commonwealth Office
London SWIA 2AH

18 February 1998

Dr. Muriel Wade-Smith
7 Hillsdale Estate
Smith's Parish, FL 02
Bermuda

Dear Dr. Wade-Smith,

Thank you for your letter of 5 February addressed to Baroness Symons, who has asked me to reply.

I read the draft copy of your book *Country without a Citizen* with interest and wish you every success with its publication.

I think your letter and your book answer your own questions; if the majority of Bermudians are of the opinion that independence is the only way for them to achieve control of their own destiny and eradicate what you perceive to be "institutionalized racism," then they are perfectly at liberty to express those views through the ballot box, either in elections or in referenda.

The British government has, at least in recent history, never stood in the way of independence for Bermuda; indeed its policy has been to remain ready to respond positively when a move to independence is the clearly expressed wish of the people. In the 1995 referendum on the independence question, only 25 percent of those people who voted supported independence, with

73 percent voting against. But should this climate of opinion change, there is no reason why a future government of Bermuda, whatever its political complexion, should not return to the independence question. In such circumstances the British government would once again maintain an impartial position and respect whatever the majority were to decide.

Yours sincerely,

M. J. Mitchell
West Indian and Atlantic Department

Letter to the Governor:

February 10, 1998

The Governor
Sir Thorold Masefield
Government House
11 Langton Hill
Pembroke HM 13

Dear Sir,

"True peace is not merely the absence of tension, but it is the presence of justice" (—Rev. Dr. Martin Luther King, Jr.).

I am sharing with you some correspondence I have sent to Great Britain and the Caribbean. I am also enclosing a draft copy of my book entitled *Country without a Citizen.*

I am a born and bred Bermudian. I have lived long enough to have been very strongly and positively influenced by my ancestors of West Indian origin, who in-

stilled in me such character traits as honesty, integrity, diligence, commitment, consistency, dedication, determination, and perseverance.

I attended a segregated school, Central School, which is now called Victor Scott Primary School. I also attended a segregated high school, the Berkeley Institute. Regardless of this, I was taught by some sterling, thoroughbred, Bermudian and West Indian teachers, who not only impregnated me with a deep desire to learn, but who also told me to aim to the highest heights and to be the best in whatever field of endeavor I chose as my life's career. Above all, they made me believe that the color of my skin should not hinder me from achieving my life's goals.

How I wish they had been right. Their intentions were noble. Unfortunately, they did not realize that as a little Black girl growing up in a British colony, there was never a level playing field for me. They did not understand that there were three strikes against me. I was Bermudian, a woman, and Black.

Over the past twenty years, as I have tried to secure a job in my native land, I have traveled the road of discovery. What did I discover? I discovered that there are two viscous ills that have worked against me. They are racism and colonialism.

Joseph Barndt, in his book entitled *Dismantling Racism: The Continuing Challenge to White America*, states, "Racism is an evil weed sown in the garden of humanity. It has grown wildly, entangling the healthy plants and covering the pathways, creating a great maze, a labyrinth with twists and turns that have led humanity astray. Racism has enslaved and entrapped us all."

Yes, in spite of being competent, capable, committed, and qualified, I have been subjected to the three

levels of racism that Barndt describes in his book. He states, "In every institution there are three distinct levels at which racism may be operating: attitudes and actions of personal; policies and practices; structures and foundations. The last is the deepest of the three, for it embodies an institution's purpose and the philosophical basis for its operation."

I believe racism and colonialism have virtually crushed the very soul, the very heart, the very pulse of existence, and the very essence of life out of Bermudians. Black Bermudians have the additional disadvantage of being denigrated to second-class citizens: first-class men. Foreigners continually displace Bermudians in their native land. Alas! Bermudians are treated as citizens without a country in the land that their forefathers helped to develop and build by the sweat of their brow.

Is there hope for Bermuda? Yes, there is hope. I believe in a God of freedom, a God of justice, and a God of equality. He is the only One who can rectify the insults, indignities, and injustices that have been meted out to Bermudians, women, and Blacks in the history of this country.

I am sending you a draft copy of my book entitled *Country without a Citizen*. After you have read it, I would welcome the opportunity to come and discuss the book with you.

I want you to know that I bear no one any ill will. There is a scripture found in Romans 8:28, which says, "And we know that all things work together for good to them that love God, to them that are the called according to His purpose."

How could what happened to me in my island home, over the past twenty years especially work for my good? Hopefully, the sacrifices I have made and the opposition

I have faced may alert and awaken Bermudians, women, and Blacks to the need for Bermuda to be restored to an island that takes care of its citizens, Bermudians. Then, and only then, will I feel we have a Team Bermudian.

Thank you for your attention. I eagerly anticipate your response.

Sincerely,

Dr. Muriel M. Wade-Smith

Enclosures

I also sent similar letters to the editors of *The Times* and *The Independent*, two newspapers in the United Kingdom. Letter to the editor of *The Times*:

January 30, 1998

The Editor
The Times
1 Pennington St.
London EI 9XN
United Kingdom

Dear Sir or Madam,

"True peace is not merely the absence of tension, but it is the presence of justice" (—Rev. Dr. Martin Luther King, Jr.).

As a result of several articles, regarding citizenship for citizens in British Dependent Territories, which appeared in my local newspaper, the *Royal Gazette,* I felt a strong compulsion to send draft copies of my book en-

titled *Country without a Citizen* to the Rt. Honorable Robin Cook, Secretary of State for Foreign and Commonwealth Affairs; and the Rt. Honorable Jack Straw, MP, Secretary of State for the Home Department. I noted that your paper and another newspaper, *The Independent*, had also carried articles regarding the citizenship issue. I also feel a strong compulsion to send you a draft copy of my book.

It is my humble opinion that the real issue is institutionalized racism in a British colony, which not only contributes to Bermudians being displaced by foreigners in the land of their birth, but also this colonial system has always regulated Blacks to that inferior status of being second-class citizens in their native land and "citizens without a country" in the land of their birth.

For the cause of freedom, justice, and equality, I believe your newspaper can come up with a very interesting article. May I suggest that you talk to Dr. Eva Hodgson? She is the author of the book, *Second-Class Citizens: First-Class Men*. She can be contacted at 441-293-2423. Another person, whom you might find quite interesting to talk to, is Mr. Walton Brown. He is a lecturer at the Bermuda College and can be contacted at 441-236-9000.

I wait with eager anticipation and look forward to reading a great article produced by your newspaper about this very important and vital question of citizenship for the citizens of British Dependent Territories.

Yours sincerely,

Muriel M. Wade-Smith

Enclosures

Response from *The Times:*

The Times
1 Pennington Street, London E1 9XN
Telephone: 0171-782 5000 Fax: 0171-782-5046

24 February 1998

Dr. Muriel M Wade-Smith
7 Hillsdale Estate
Smith's Parish, FL 02
Bermuda

Dear Dr. Wade-Smith

Thank you for writing to the Editor of *The Times* on February 5. Your comments have been carefully noted.

Yours sincerely,

pp. Ivan Barnes
Letters Editor

I was quite elated when I received a phone call from Dr. Eva Hodgson. She told me that she supported my fight and gave me the following letter:

18 Abbot's Crescent
Hamilton Parish, CR 01
BERMUDA

February 14, 1998

Rt. Hon Robin Cook
Secretary of State for Foreign and
 Commonwealth Affairs
Foreign and Commonwealth Affairs Office
Whitehall, London SWIA 2AH

Dear Sir,

 I have received correspondence from Dr. Muriel Wade-Smith. She indicated that the promise of full British citizenship is not the most significant issue that faces Bermudians. The most pressing issue is the policies, practices, structures, and foundations of the government of Bermuda that perpetuate institutionalized racism.
 Having experienced similar difficulties as Dr. Wade-Smith in attempting to secure a job in my home country, I wholeheartedly support Dr. Wade-Smith in her efforts to expose the corrupt, unfair, and unjust system in Bermuda.
 The disparity of wealth and power existed during slavery and segregation continues to exist. Even though Universal Adult Suffrage brought about the desegregation of public facilities, such as hotels, restaurants, and theatres, there is still this tremendous economic disparity.
 Democracy is an illusion in Bermuda because of this disparity. A certain percentage of the population is excluded from economic prosperity. If one supports the United Bermuda Party, however, he may be given the opportunity to share in the economic pie.
 The powerful "White Front-Street merchants" control all economic opportunities, all professional opportunities, and all loans and finances. They are the United Bermuda Party. They are one and the same.
 In reality, both political parties, the United Bermuda Part and the Progressive Labor Party, represent racial in-

terest. Most Whites, 95 percent, probably support the United Bermuda Party, while most Blacks, probably 75 percent, support the Progressive Labor Party, even though we have a Black woman Premier and several Black Cabinet ministers.

At a personal level, I wish to support the argument based on my experience during the eighties and nineties. I am a highly qualified, competent, and capable individual with academic degrees from Colombia and London University.

When I returned home, I was totally unable to obtain appropriate professional job positions. In 1980, I was told unabashedly by a top civil servant that I could not be employed because "White Front Street disapproved."

In 1990, an extremely influential bank officer, who was a member of the Public Service Commission, told me I was denied because I was "too Black."

For almost a decade, I applied to the Bermuda College for a variety of positions. White expatriates frequently displaced me.

More recently, ironically enough, I proposed a ministry to deal with race relations. This was after Bermuda went through a decade of denial. For, Sir John Swan, a Black Premier, stated that there was "no racism" in the country, because we had a Black Premier.

In 1993, he finally succumbed and established the Ministry of Human Affairs. This ministry was established to deal with race relations and drugs.

Since 1993, I have consistently applied for a position in this ministry. In spite of the fact that it was my brainchild, I consistently have been denied.

This ministry has addressed all of its efforts toward workshops geared to the wealthy business community, which vigorously resists change, instead of providing general education to the general population that wants change.

Their most recent gimmick was to invite three White people from Ireland to Bermuda to tell us how to solve our race problem. Ireland's problem is not a race problem; it is a religious problem. This is one more effort to minimize and ignore Bermuda's race problem by discussing religion.

I give Dr. Wade-Smith's correspondence further support, not because I believe you will have the slightest interest in Bermuda's racial problem, when the majority refuses to solve the problem themselves.

Yours sincerely,

Dr. Eva Hodgson

In the July 29, 1998, edition of the Wednesday edition of the *Bermuda Sun*, I read with interest an article entitled, "Perinchief to Run as Independent." It was written by Avo Johnson. I feel that Mr. Perinchief's comments shed a broader light on the question of full British citizenship. Following are excerpts from the article, which include some of his remarks:

Lawyer Phil Perinchief is set to enter the political fray as an independent candidate. And he says he hopes his bid would put the issues of independence, British citizenship, and income tax on the front burner—issues he says are being avoided by both political parties because of political expediency.

Top-of-the-list issues that Mr. Perinchief wants on the political agenda is Bermuda's future relationship with Britain.

"Independence or full British rights is the single most divisive threat to Bermudian society as we know it today," he said. While he prefers that Bermuda opt for in-

dependence, he said at the very least, the Bermudian
people should be given the option to choose between
British citizenship and independence. And the question
should be put on the ballot, he said, noting that the PLP
had argued against a referendum on independence in
favor of it being decided by a general election.

An offer of British citizenship is a "Trojan horse"
that "Bermuda should reject out of hand," he said, be-
cause reciprocity is bound to follow. As signatory to the
European Convention of Human Rights, a treaty which
rejects colonialism, he said Britain will be pressured by
the European Union to remove all colonial binds. This
could be done by forcing reciprocal rights in Bermuda
for Europeans or Independence, he reasoned.

A debate at that stage—where some Bermudians
would have opted for the British passport—could lead
to civil unrest and violence.

And he declared both the UBP and the PLP "gutless
for adopting a wait-and-see attitude on an issue that's
far more important than the election."

Chapter 7

Justice Begins to Flow

Our efforts to overcome racism must begin in our own sanctuaries and continue beyond the church to create a nation and a world in which all races and cultures are included, accepted, and enabled to live together in equality and harmony.

—Joseph Barndt

CURRICULUM COORDINATOR AT LAST

On January 6, 1998, I flew to Dallas, Texas. I was invited there by Dr. Donald Howard, the Founder and former President of School of Tomorrow. His invitation had come at a time when I felt like I was in the valley of despair. In desperation, I had pointed my finger at God and had said, "God, I'm prepared to go to hell until You prove to me that You are a God of freedom, a God of justice, and a God of equality."

For twenty years, I had struggled against insurmountable odds, trying to secure employment in my country. I felt utterly hopeless and helpless. I had written letters upon letters to church leaders and government officials. I had filed

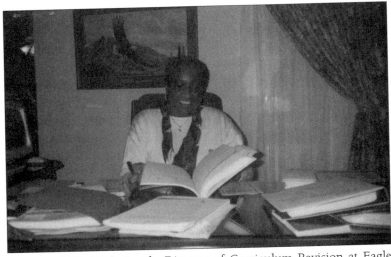

Dr. Muriel M. Wade-Smith, Director of Curriculum Revision at Eagle Educational Reform Learning Systems, Inc. in Lewisville, Texas.

two complaints with the Human Rights Commission. All of it was to no avail. Why in the world was I born? Why in the world did I even bother to get a doctorate? I had virtually lost twenty years. Why couldn't I get a job in my country?

It wasn't until I hit the cancerous roots, the evil weeds, of institutionalized racism and colonialism that God picked me up and sent me to Lewisville, Texas, to work with Dr. Donald Howard, one of the world's leading influences in educational reform.

Dr. Howard—a graduate of Bob Jones University and a former teacher, principal, college president, and vice president— had founded the School of Tomorrow in Garland, Texas, in 1970. Under Dr. Howard's leadership, the School of Tomorrow had grown from one school in 1970, to seven thousand schools in 110 countries. The corporate staff had grown from 3 employees to 350. The facility had expanded

from one small school to a four-acre plant on a three hundred-acre campus ten minutes north of Dallas/Fort Worth.

The curriculum, developed from a cut-and-staple of pac materials, has gone through three editions of new curriculum development for all subjects and all grade levels at a cost of fifty million dollars in twenty-seven years.

Under his leadership, the first high-tech, computer-video, interactive, high-school math and science curriculum was developed. In the last five years, Dr. Howard has met with thirty-two national Ministers of Education and has signed fourteen contracts to involve the School of Tomorrow as part of the National Educational Reform Program in 150 government schools worldwide.

In 1997, Dr. Howard retired from the School of Tomorrow to become a consultant to bring education reform to the United States public schools and to establish model schools for Educational Reform.

Dr. Howard is the Founder and President of Eagle Educational Reform Learnimg Systems, Inc. He serves as a consultant and a member of the board of the Eagle Project Open Enrollment Charter School.

Eagle Educational Reform Learning Systems, Inc., was founded in 1996 for the purpose of implementing educational reform in the public schools of America, through the use of high-tech, individualized, diagnostically prescribed curriculum and programs.

Eagle Educational Reform Learning Systems, Inc., produces, markets, sells, and distributes supplemental and core academic learning tools through retail bookstores and bookstore learning centers, through public-school contract projects, experimental programs, and high-tech learning centers in public schools, under the control of local school

districts and state boards of education, and by establishing model charter schools under state laws.

The partnership programs of Eagle Educational Reform Learning Systems, Inc., bring together private and public education, integrating the best of traditional basics; mastery learning; high technology; and traditional, historic, Western values within the contemporary system to provide educational reform for the twenty-first century.

In the Eagle Project Charter Schools brochure, the Charter School Program is described as follows:

> This High-Tech Learning Center provides a twenty-first-century education for students who qualify to attend this free, local public school, sponsored by the Texas State Board of Education.
>
> Introducing "personalized education" to meet the needs of each individual student. Designed for a generation of youth destined to carry the nation into the Information Age but who are now having problems succeeding in a nineteenth-century, conventional, lockstep, chronologically graded classroom.
>
> This "modern" classroom, which came to the United States from Prussia in the 1800s, is as out of date as the horse and buggy, is failing more and more students each year, and cannot take this generation into the computer age. Thirty-seven percent of all Texas school children are labeled, as "at risk" of dropping out, and more graduates are not qualified to attend the university.
>
> More than ten thousand learning centers have been opened in 110 countries, using this personalized, diagnostically prescribed learning system. This personalized, high-tech learning center is designed to meet the needs of these diverse youth.
>
> The curriculum was developed through three major editions and has been used successfully by millions of

children in private schools, equipping them to attend more than five hundred colleges and universities. . . . It is now being revised into a new, loose-leaf "Public School Edition" with software and multimedia.

The Eagle Project's board of internationally known educational leaders is committed to setting up high-tech learning centers of the Eagle model, in every school district in the state to reach so-called at-risk and adjudicated students, dropouts, and high school graduates who do not yet qualify to attend the university. The centers will serve as models to demonstrate personalized education and to introduce educational reform to each city.

In January 1998, I spent a week at Eagle Educational Reform Learning Systems, Inc. This was when this exciting project was launched. I am extremely grateful to Dr. Howard for giving me the opportunity to be a participant in this movement aimed to bring about educational reform in the public schools of America.

From February until June, I was in Texas as an International Curriculum Consultant and the Director of Curriculum Revision. While Texas is not my favorite state, the fulfillment, stimulation, motivation, and enthusiasm I experienced while working on the project was most rewarding. I've had the opportunity to see a project develop from the beginning and foundation stage.

Words are inadequate to express the true sentiments of my heart about my involvement in my life's career work. Just when I thought it was impossible, just when I thought it was useless to have gotten a doctorate with a major in curriculum, just when I thought I would never work in the area for which I was qualified . . . after twenty years, my dream became reality. What is even more mind-boggling are the achievements, accomplishments, and qualifications

of the people with whom I was working! In such an atmosphere, all the feelings of rejection by the various individuals in my country were obliterated. The spark that I had for curriculum was reignited. I remember Dr. Howard saying, "You have come here and taken to this curriculum work, just like a duck takes to water." Sometimes, I would walk around the offices at Eagle Educational Reform Learning Systems, Inc. and pinch myself to assure myself that I was not dreaming.

One of my first responsibilities was to look through the second edition of the School of Tomorrow curriculum for religious expressions and confessionalism. Since we were going to be financed by the state as a charter school, we were required to bring the curriculum into compliance with state regulations. Since the School of Tomorrow was a program produced for Christian schools mainly, the curriculum was laced with scripture throughout the textbooks.

I vividly remember Dr. Howard's criteria of religion and reality. He said that religion was man trying to reach God, while reality was God coming down to man. If it is religion, it has to be removed; but if it is reality, it can stay. We spent many hours discussing what was religion and what was reality. To me, it was a whole process that I had to go through. Sometimes I thought, *Why do we have to take this out?* Then, there were times when it was too painful to remove anything from the math, science, social-studies, and English curricula. I must admit that there were times when I felt like crying, because I felt the children would be losers if they did not have the benefit of some of the religious instruction.

As I did the religious analysis of the curriculum, I developed an even greater appreciation for the quality of it. Math

was by far the easiest of the curricula to complete. The English curriculum had most of its example sentences couched in scriptural terms. My recommendation was that much of that curriculum had to be rewritten. The inevitable question of creation versus evolution rose in the science curriculum. But the hardest job was the social-studies curriculum. It was loaded with a great deal of religious expression, and my recommendation was that something entirely different had to be found for the children in the inner city.

It was quite a challenge, and in June I felt like I had reached the pinnacle and zenith in my career as a Curriculum Consultant. I had recommended all of the necessary revisions. All systems were go for the production of the new curriculum. In some areas where there were scriptural references, we replaced them with positive, character-building statements. Toward the end, as I leafed through the revised edition, I somehow felt the way I used to feel when I had gone to school. While it was not called a Christian school in my school days, our teachers dutifully instructed us in the importance of such character traits as honesty, kindness, consistency, determination, compassion, and many, many others. I sensed that we were providing the children with a foundation that would help them to become future leaders of character for the country.

Things were going so well. I remember talking to my younger son, Ashanti, in April. He said, "Mommy, why are you coming home? You sound so happy. Why don't you stay out there."

I said, "I'm ready to come home to see you guys. I really miss you while I am out here. I also need to see your gramlins" (Ashtani's nickname for his three children).

He assured me that they were all OK.

I returned to Bermuda for two weeks. That was the last time I saw my youngest son, Ashanti alive. On May 2, while I was in Texas, I received the news that he had been killed in a traffic accident. His long time, childhood friend had been driving a vehicle that had collided with another vehicle, and Ashanti had died two hours later in the hospital.

That night, in spite of the difficulty I had sleeping, I did experience a period of peace and calmness, during which I sensed Ashanti saying, "Mommy, I'm OK. Don't forget you gave me Christian education."

I returned home to make the funeral arrangements for my son. I hope I never have to take a flight under such circumstances ever again. I remained in Bermuda for two weeks after the "celebration-of-life service" for Ashanti. Then, I went back to Texas. Somehow, it was most difficult for me to remain focused. In spite of the job situation being something I had wanted so desperately, I could not function efficiently and effectively.

One morning, on my usual walk, I could hear the words from the tape produced by Dr. David Gibbs. The tape was called *Preference or Conviction*. I remember Dr. Gibbs saying, 'When Christian education is a conviction, family, friends, money, threat of a lawsuit, jail, and not even death will hinder you from holding on to your conviction.' When I heard that tape in the eighties, I remember settling, "Yes, Lord, not even death would hinder me from doing Christian education."

I began to cry uncontrollably. Could it possibly be that Ashanti's death had to take place so that I could carry out my dream of Christian education for the children of Bermuda? I thought that perhaps *I* would be required to die for the cause of Christian education. The reality, the death of my baby son,

struck me a full blow. Not me, but the life of my young son was the price I had to pay for my vision for Christian education. My son, a part of me—the ultimate grief was the price of my dream becoming reality. As painful as it was, it brought some degree of meaning to what I had perceived as a meaningless, senseless, and untimely death.

As some measure of significance began to surround the death of my son, the thought of returning to Texas began to fade into the background. I share with you a letter that I wrote to the editor of the local newspaper, the *Royal Gazette*. I had reached the place where my vision for Christian education in Bermuda had been rekindled. I knew I had an obligation to fulfill my son's request for Christian education for his children—my grandchildren.

Letter to the editor:

18 June, 1998

The Editor
Royal Gazette
2 Par-La-Ville Road
Hamilton HM 08

Dear Fellow Bermudians,

"Neither do men put new wine into old bottles: else the bottles break, and the wine runneth out and the bottles perish: but they put new wine into new bottles, and both are preserved" (Matt. 9:17).

The time has come when I must share with you a philosophy, an educational principle, and an objective for Bermuda's educational system that were established in 1948. Dr. Yvonne Blackett, a dedicated and committed Bermudian educator and I came across these statements while we were pursuing doctoral studies at Miami Uni-

versity in Oxford, Ohio. Needless to say, our righteous indignation was stirred.

In 1952, in an unpublished dissertation entitled, "History of Education in Bermuda," the late Dr. Kenneth Robinson, a Harvard graduate, stated, "From the outset the system has been diversified both with respect to purpose and structure." In addition, Dr. Robinson found it necessary to list major special education objectives with which colored Bermudians should be concerned.

Dr. Yvonne Blackett, in an unpublished report dated May 1976, indicated that official documents in 1948 revealed implicit and explicit indications of the following:

- Philosophy of Education 1948: schools should be for the maintenance of the social, economic, and political status quo
- Educational Principles 1948: that of social, economic, and political dominance by White people
- Educational Objectives 1948: to cultivate White children for hereditary leadership

Just recently, after hearing that two exempt companies, EXEL and ACE Ltd., were donating two million dollars to Saltus Grammar School, a historically, predominantly White private school, to reserve ten spaces for the children of the staff of these two companies. I asked myself, *Has the situation changed since 1948? Has the situation remained the same, or has the situation gotten progressively worse?* I fully understand the dilemma and plight of those companies. However, I totally disagree with their actions. Every parent wants quality education for his or her children.

Allow me to make a suggestion. This is not just confined to the two exempt companies, but any company

or any persons who want all of Bermuda's children—
Blacks, Portuguese, and Whites, not just the "elitist
few"—to be the beneficiaries of a world-class curricu-
lum and program that meets the educational needs of
today with the traditional values of yesterday and the
technology of tomorrow.

Form a partnership with me! Back me with two mil-
lion dollars. and I guarantee you I'll not only make a dif-
ference in the academic achievement of all of Bermuda's
children, but I will turn over to you some character-rich
young people, future leaders of this country, whose lives
will show the importance of such character traits as com-
mitment, punctuality, diligence, cooperation, honesty,
responsibility—and many, many others.

Over the past six months I had one of the most won-
derful opportunities of my life. I was the guest of Dr.
Donald Howard, one of the world's leading influences
in educational reform. He was the founder and presi-
dent of the School of Tomorrow for twenty-seven years.
He led the company from one school with forty-five stu-
dents in 1979, to opening over seven thousand schools
in 110 countries.

He also led in the development of three editions of
interactive, individualized, high-tech curriculum at a cost
of sixty-five million dollars. The schools successfully
graduate fifteen thousand seniors a year to attend and
excel in five hundred colleges and universities worldwide.

In 1997, Dr. Howard retired from School of Tomor-
row to become a consultant to bring educational reform
to the United States' public schools and to establish
model schools for educational reform. He is now the
founder and president of Eagle Educational Reform
Learning Systems, Inc.

Over the past week, I have renewed my association
with certain officials at School of Tomorrow, Inc., and

have indicated to them my willingness to assist in establishing a model School of Tomorrow in Bermuda.

From 1983 until 1994, I used the curriculum and program produced by School of Tomorrow. I had tremendous success. It is an individualized, diagnostically prescribed curriculum with tools for the high-tech era and a mastery level components, laced with traditional and historic values.

When Ashanti, my youngest son, was six years old, he said, "Mommy, I hate to tell you this, but school is boring. I have a better idea: why don't you let me stay at home, and you teach me?" It took me four years to grasp the significance of what he was saying. I finally got the message. So, when Ashanti was ten and Gareth, his older brother, was fifteen, I received permission to take them out of the public school system and to teach them myself. I placed them on the School of Tomorrow curriculum and program.

About a year ago, my two sons stood by my bedside and said, "Mommy, what you did for us was the best thing that happened to us. It's the only thing that worked for us, and that's what we want for our children."

I have been reluctant to pursue further involvement with education in Bermuda. I've felt like a citizen without a country and a prophet without honor in her own country. Over the past weeks, however, I have been experiencing a change in heart. What has caused this?

About six weeks ago, my youngest son, Ashanti became Bermuda's seventh road fatality. I have been haunted by the memory of him telling me that what I had given him was the same thing he wanted for his children. With Ashanti's passing, I feel duty bound and responsible for seeing that his children receive the same kind of education that I gave him.

I'm not selfish. Just as I did not provide quality education for my children only, I would not provide quality education just for Ashanti's children. I love to see children learn. The color of their skin and their status in life should not be obstacles preventing children from receiving quality education.

Some sterling, thoroughbred Bermudian and West Indian teachers who made a tremendous difference in my life taught me. They instilled in me the joy of learning. They also taught me to aspire to the highest heights. They let me know that under no circumstances must I allow the color of my skin to deter me from achieving my career goals. Those veteran teachers were of the old stock that virtually dedicated their lives to teaching and seemed to regard it as a calling. It appeared that they felt grateful to God for the opportunity to touch a child's life. As a result, there was a keen awareness of being accountable to God for each child entrusted in their care.

To teach for money was unheard of then, and such a despicable thought would not even be entertained. They taught for the love and joy of teaching. Out of gratitude to those wonderful people who had a significant influence on my life, I have always wanted to give something back to the children of Bermuda.

Therefore, I challenge all Bermudians who want all of Bermuda's children to be afforded the opportunity to be involved in one of the world's leading curriculum and programs, to support me. I need financial assistance to do this. I'm too old to mortgage my house at this stage of the game. I can't work for five hundred dollars a month anymore, and to work for nothing is contrary to the biblical admonition that states, "The laborer is worthy of his hire."

My vision has been rekindled. Was Ashanti, my baby son, the "sacrificial lamb" that had to be slain so that I could see my dream become reality?

Before I close, let me add that my son Ashanti, by his example, taught me one of life's most valuable lessons. It is this: Love causes us to forgive until there is no more pain. Then, comes the peace. I have forgiven all of my countrymen for the insults, injustices, and indignities meted out to me, including the United Bermuda Party; the Progressive Labor Party; church officials; certain persons from the Ministries of Education, Health and Social Services and Community Affairs; certain members who served on the Public Service Commission; family; friends; relatives; and even my enemies. Let me hasten to add that in my struggle for freedom, justice, and equality, I have annoyed, vexed, and irritated many of you. [To you I say,] "I'm sorry. Please forgive me."

During the eighties, there was a poem that propelled and undergirded me. It has resurfaced over the past six weeks. I share it with you: "When God gives a *vision* / He makes *provision* for the *vision* / There's no *division* / And I must stay *positioned* / With the *vision* / To see it to *fruition.*"

Thanks for your attention and support.

Academic excellence for all,

Dr. Muriel M. Wade-Smith

Even though, I had settled that I was going to remain in Bermuda for the time being, there was something that kept needling me. It was my last unsuccessful attempt in applying for a job in the Ministry of Education. (My unsuccessful job application for the position of Education Officer for Social Studies is recorded earlier.)

So I went to the Human Rights Office to see about lodging a third discrimination complaint. I guess the phrase

"Three strikes and you're out" readily applies to the response I received from the Human Rights Commission. Once again, I heard that still, quiet voice prodding me by saying, "The pen is mightier than the sword." So I share with you the following letters. I thought, *Maybe these are the last writings I have to do before justice begins flowing on my behalf.*

Letter to the Investigations Officer:

July 9, 1998

Mr. David Wilson
Investigations Officer
Human Rights Commission
Suite 301, Mechanics Building
Church Street, Hamilton HM 12

Dear Sir,

Thanks so much for your time and attention at our meeting yesterday. The discussion was very productive and most enlightening with respect to my recent intention of filing a third complaint with your department regarding my unsuccessful attempt to obtain the job of Education Officer for Social Studies.

After much careful thought and consideration, I have concluded that in relation to filing the discrimination complaints about my situation, the deck is stacked against me and heavily favors a government that has policies, practices, and procedures that perpetuate institutionalized racism. It is my humble opinion that your organization does not have the power to deal with Bermuda's problem of institutionalized racism. Consequently, I have no other recourse but to appeal to a higher authority.

I am enclosing a brochure that shows I am an International Curriculum Consultant for Eagle Educational Reform Learning Systems as the Director of Curriculum Revision. I find it rather interesting that I can be appreciated and used for my competencies, skills, qualifications, experience, exposure, and expertise in another country. In spite of being Bermuda's first qualified curriculum coordinator, I have not been afforded the opportunity to give something back in the area of my expertise to the country that produced me.

Thanks very kindly for your attention.

Let justice flow,

Dr. Muriel M. Wade-Smith

Enclosures

CC:
The Premier, the Hon Pamela Gordon, JP, MP
Miss Jennifer Smith, Opposition Leader
Canon James Francis, Commissioner of the
 Human Rights Commission
Mr. Kenneth Dill, Executive Director of the
 Human Rights Commission
Mr. Ken Spurling, CURE
Dr. Eva Hodgson, Director, National Association for
 Reconciliation
The Hon. M. Timothy Smith, JP, MP, Minister of
 Education

Was this the end? No! I kept hearing the words "the United Nations." Then I remembered their declaration to combat racism. I decided I must write them, too. Here is the letter.

Letter to the Officer of the High Commissioner for Human Rights:

July 9, 1998

Officer of the High Commissioner for Human Rights
Palais Des Nations
8-14 Avenue
De La Paix CH 1211
Geneva 10, Switzerland

Dear Sir/Madam,

"In every institution, there are three levels at which racism may be operating: attitudes and actions of personnel, policies and practices; structures and foundations. The last is the deepest of the three, for it embodies an institution's purpose and the philosophical basis for its operation" (—Joseph Barndt).

In a recent address at the Bermuda College, Dr. Pauulu Kamarakafego stated, "We should remember that the United Nations passed a resolution creating the Decade to Combat Racism from 1994 to 2003."

Over the past twenty years, in spite of being two of Bermuda's most highly qualified, competent, capable, and committed educators, Dr. Eva Hodgson and I have failed to secure employment in our native land. Oft times, we have been overlooked by less competent expatriates. Filing complaints with the Human Rights Commission is an exercise in futility.

Consequently, I called the United Nations and I was given this address. Please send me information regarding the procedures that must be followed so that an organization of your caliber and one with your commitment to combat racism can help us to eradicate the evils of insti-

tutionalized racism in this country. There was mention made of a meeting being held in April of next year. Would it be possible for Dr. Hodgson and I to be involved in making a presentation to your organization?

I have enclosed some materials for your perusal. I eagerly anticipate your response so that we can work together to wipe out this demonic ill that is destroying our society, and make Bermuda a better place for our children and the generations following.

Thanks very kindly for your attention.

Sincerely,

Dr. Muriel M. Wade-Smith

Enclosures

CC:
The Premier, the Hon. Pamela Gordon, JP, MP
Miss Jennifer Smith, JP, MP, Opposition Leader
Canon James Francis, Commissioner for Human Rights
Mr. Kenneth Dill, Executive Director for Human Rights
Mr. David Wilson, Investigations Officer for
 Human Rights
Mr. Ken Spurling, CURE
Dr. Eva Hodgson, Director, National Association for
 Reconciliation
The Hon. M. Timothy Smith, JP, MP, Minister of
 Education

This must be the end of my writing for now, I thought. I was wrong. I received the nicest birthday present. For, on my fifty-ninth birthday, July 13, a letter I wrote to the editor on July 1 appeared in the *Royal Gazette.*

July 1, 1998

The Editor
Royal Gazette
2 Par-La-Ville
Hamilton HM 08

Dear Sir,

"Racism is an evil weed sown in the garden of humanity. It has grown wildly, entangling the healthy plants and covering the pathways, creating a maze, a labyrinth with twists and turns that have led humanity astray. Racism has enslaved and entrapped us all" (—Joseph Barndt).

Over the past twenty years, Dr. Eva Hodgson and I have been the victims of "institutionalized racism." In spite of presenting our situations to the Human Rights Commission, we have been unable to receive justice and compensation for the insults, injustices, and indignities meted out to us.

Sad to say, Bermudians—Black, White, and Portuguese—have stood quietly by and watched as we have been subjected to outright, blatant forms of institutionalized racism. Dr. Hodgson, a well-qualified, astute, and competent educator, has been denied the opportunity to make a very worthy and valuable contribution to her country in her area of expertise, Black history. [Similarly] I . . . have not been afforded the opportunity to provide a Black studies curriculum for the children of Bermuda.

The past twenty years have been a very enlightening and informative experience for me. I've realized that my struggle not only has been to secure a job in this country, but my struggle also has been to expose the corrupt political, economic, social, and religious systems of my native land. While the rejections have been most

painful and bitter, thank God, I have finally found peace. Just recently, my youngest son, Ashanti Keino Smith, became Bermuda's seventh road fatality at the tender age of twenty-five. By his example, he taught me one of life's most valuable lessons. It is [this]: Love causes us to forgive until there is no more pain. Then, comes the peace.

Consequently, I have forgiven all of my fellow countrymen—the United Bermuda Party; the Progressive Labor Party; church officials; certain persons in the Ministries of Education, Health and Social Services and Community Affairs; certain members of the Public Service Commission; family; relatives; friends; and even my enemies. In my struggle against institutionalized racism, I know I have offended, annoyed, and vexed many of you. [To you, I say,] "I'm sorry. Please forgive me."

This, however, does not alter the fact that I have been wrongfully treated in my country. As a result, I ask, "Why should people, such as Dr. David Saul; Dr. George Cook; Dr. Archie Hallett; Mr. Mansfield Brock; Mr. Sinclair Richards; Miss Ruth Thomas, MBE; the Honorable Quinton Edness, CBE; Mr. Lowdru Robinson, to name a few, be paid out of the public purse as beneficiaries of institutionalized racism, when Dr. Eva Hodgson and I, the victims of institutionalized racism, have not received justice or any form of compensation?"

Fellow Bermudians, the ball is in your court. Until Dr. Hodgson and I receive justice and compensation for the institutionalized racism meted out to us, there will never be justice and equality for any Bermudians. No man is free until all men are free, and there cannot be justice for all if there is even injustice for one person.

May our lives serve to awaken us to the urgency of ending racial injustice and racial inequality in our country, and never again in the history of this island will Ber-

mudians—Black, White, or Portuguese—be the victims of institutionalized racism.

Let justice flow,

Dr. Muriel M. Wade-Smith

At this point, I was driven by a compelling force to do something that I thought I would never have the opportunity to do in my life. I had a deep, burning desire to provide Christian education, not only for my grandchildren, but also for any child in Bermuda whose parents desired quality education for their children.

Ashanti's words haunted me continually. I always felt I had completed my task when I took my children out of the public school system and gave them Christian education, and I believed it was up to my children to provide Christian education for their children. Did Ashanti leave me holding the bag?

WORLD EDUCATION REFORMER

Have I been challenged afresh? Yes, Ashanti's death has rekindled the flame for Christian education in me in a deeper and broader sense. The tents of Christian education have been enlarged.

Over the past twenty-seven years, in School of Tomorrow's thrust to "build world changers," many, many Black children have been denied the chance to obtain Christian education. Consequently, my vision now is to reach not only my grandchildren, but also all the children of Bermuda. Not only do I want to set up high-tech learning cen-

ters in the island of St. Kitts, I also want to set up high-tech learning centers for all the children in the Caribbean.

I have always wanted to go to Africa, ever since I was a teenager. Yes, I want to do whatever I can to help the children of Africa get Christian education, I've renewed my commitment to help on that continent. Then, I also have a burning desire to help the children not only in the inner cities of America, but I also want to help the children in the inner cities of the world.

From 1983 until 1994, when I attended conventions and seminars arranged by the School of Tomorrow, my heart was always crushed and wounded. I saw very few Black pastors involved with this curriculum and program that would challenge young people to turn their hearts back to God. My heart's cry to God was, *Lord, where are the Black pastors? I know You are not a prejudiced God. Surely, Black children need this program as much, if not more, than White children.*

Years later, out of a sense of desperation and utter frustration, I pointed my finger at God and said, "God, I'm settled to go to hell until You prove to me that You are a God of justice and a God of equality."

Indeed, the Black harvest is ripe for Christian education. Are the laborers few? The inner cities of America and the world have become the mission fields of America and the world. Can we stand idly by and let Black children continually be deprived of receiving Christian education? Many Black pastors wanted to start Christian schools, but for them it was a question of economics. Many of them never felt they had the financial resources to have a Christian school.

Can we continue to shut up our bowels of compassion to the needs of Black pastors and Black children all around the world?

I believe I'm on the brink of the greatest miracle of my life. I will be involved in spreading Christian education all over the world. I believe I must first begin in Bermuda and then journey to the uttermost parts of the earth.

My heart has been encouraged by the correspondence and meeting I had with the Premier and the Minister of Education. Read the Premier's letter, and share the feeling of excitement I felt as I read her letter.

28 June 1998

Dr. Muriel M. Wade-Smith,
Curriculum Consultant,
7 Hillsdale Estate,
Smith's Parish, FL 02.
Dear Dr. Wade-Smith,

Thank you very much for your letter of June 18 and for sharing with me your plans to embark upon a rather interesting educational initiative, subject to obtaining the required funding to make the project a reality. I certainly hope that the project succeeds.

Bermuda has shown itself, in recent times, to be open to alternative modes of education, and providing members of the community are convinced that the approach you are recommending is a viable one, there is no reason why support should not be forthcoming.

You might find it useful to liaise with the Ministry of Education on your proposed plans, to ascertain whether you might obtain support from that particular quarter.

In the meantime, I wish you every success in your endeavors, and remain,

Yours sincerely,

The Hon. Pamela Gordon, JP, MP

I also shared my vision for quality education for Bermuda's children with the minister of education, the Honorable M. Timothy Smith, JP, MP. Since 1995 the American and the Canadian bases on the island have been vacated. Consequently, there are any number of properties that could provide facilities to house the high-tech learning centers. I envision having two high-tech learning centers—one at Kindley Field (on the eastern end of the island) and one at Daniel's Head (on the island's western end). Not only are the buildings available, but there are also the additional features of soccer fields, softball diamonds, tennis courts, and beaches. What tremendous potential exists to make a difference in the quality of education for Bermuda's children!

I could not help but feel that the responses conveyed to me by the Premier and the Minister of Education were the most receptive responses I had ever received. I felt that justice had begun to flow, and every fiber of my being shouted with a loud voice in full agreement with the scripture found in Amos 5:24, which states, "But let judgment run down as waters and righteousness as a mighty stream."

Let justice *flow!*

To order additional copies of

Let Justice Flow

Send $12.99 plus $3.95 shipping and handling to

Books, Etc.
PO Box 4888
Seattle, WA 98104

or have your credit card ready and call

(800) 917-BOOK